A Makoto Shinkai film

your name.

The Official Visual Guide

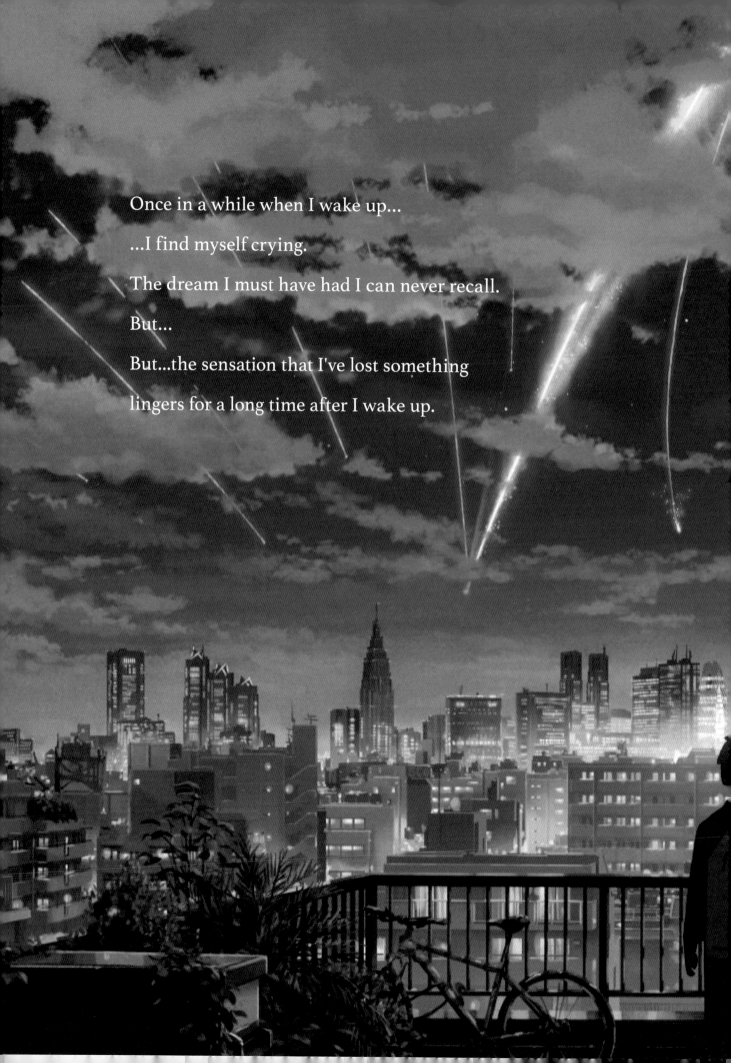

Once in a while when I wake up...

...I find myself crying.

The dream I must have had I can never recall.

But...

But...the sensation that I've lost something

lingers for a long time after I wake up.

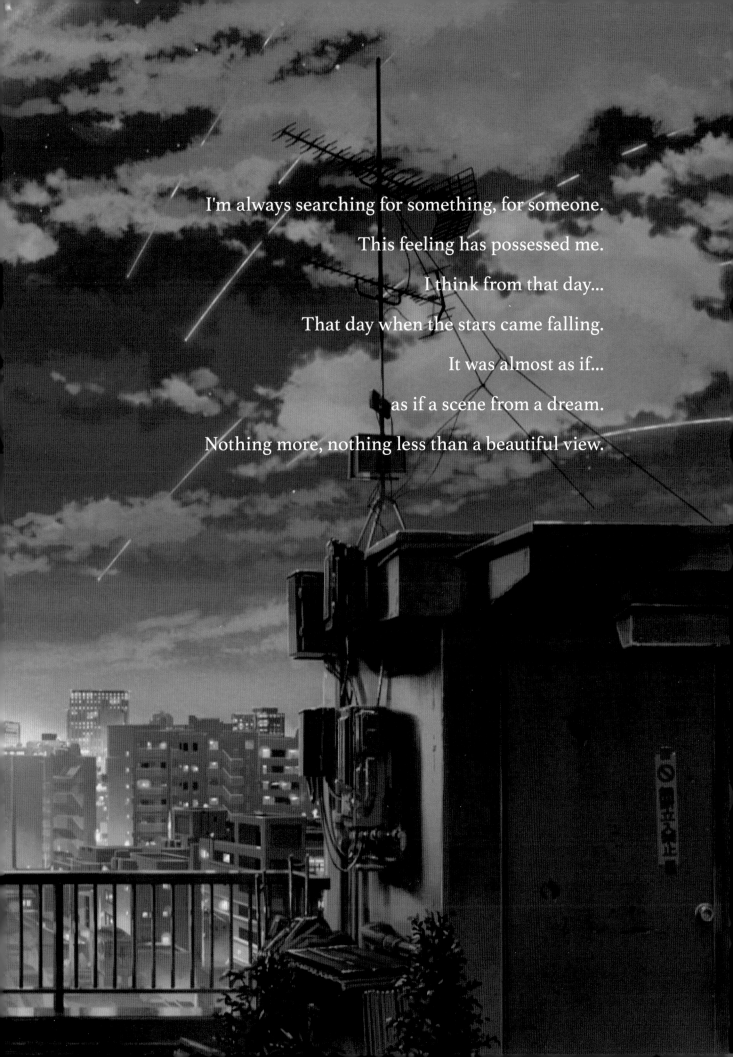

I'm always searching for something, for someone.

This feeling has possessed me.

I think from that day...

That day when the stars came falling.

It was almost as if...

as if a scene from a dream.

Nothing more, nothing less than a beautiful view.

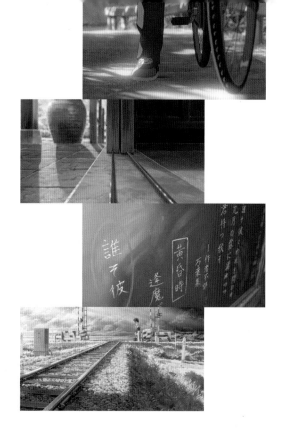

CONTENTS

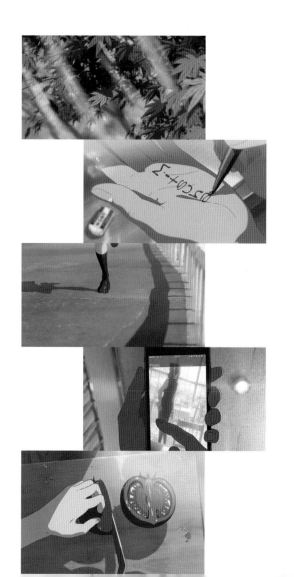

VISUAL STORY

A complete scene-by-scene overview of the entire story.
Relive your favorite scenes from the film!

"Don't you remember me?"

When Taki opened his eyes, he was lying in a futon on a tatami floor. Just before he woke up, he'd heard a girl's voice...

 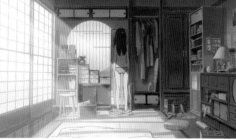 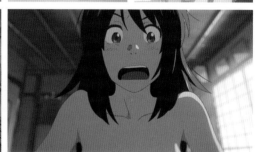

A voice calling him "Sis" woke Taki up completely; when he stripped off his pajamas in front of the mirror, he saw a naked girl...!

"WHAAA—?!"

One morning, Taki Tachibana, a high schooler from Tokyo, woke up in an unfamiliar room.
 When he looked down, he saw the body of a girl in pajamas. Was this a dream...? Still half-asleep, he automatically reached for her breasts.
 The body's actual owner was Mitsuha Miyamizu, a high schooler who lived in the rural town of Itomori, deep in the mountains, and the room belonged to her.
 The next morning, Mitsuha was herself again. Her little sister, Yotsuha, and grandmother, Hitoha, seemed relieved to see she was back to normal, but Mitsuha didn't know what they meant.
 As usual, she ate breakfast, dexterously braided her hair and tied it up with her braided cord, then left for school with her sister.

your name. | VISUAL STORY |

6

"You're normal today."

Mitsuha was late for breakfast. As she scooped rice into her bowl, she murmured, "Whoops, is this too much?" She was just like always.

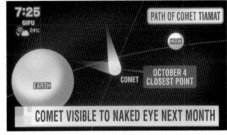

7:25 GIFU 24℃

PATH OF COMET TIAMAT

MOON

EARTH

COMET

OCTOBER 4 CLOSEST POINT

COMET VISIBLE TO NAKED EYE NEXT MONTH

When the topic of the mayoral election came up during the disaster-prevention radio broadcast, Hitoha unplugged the speaker, and Mitsuha turned on the TV. The news on TV was about Comet Tiamat, which only passed Earth once every thousand years.

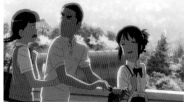

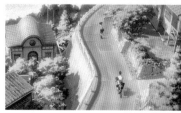

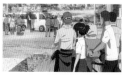

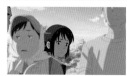

"Your hair looks all right today."

"What?"

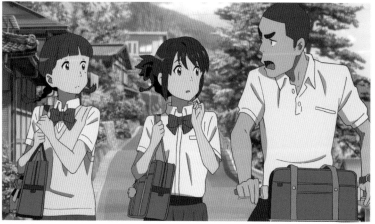

"Your hair looks all right today." "You were totally possessed!" Sayaka and Teshigawara commented on her strange behavior the previous day, but Mitsuha had no idea what they were talking about.

During his speech, Mitsuha's father told her to "Stand up straight!" As Mitsuha left, she could feel her classmates silently laughing at her.

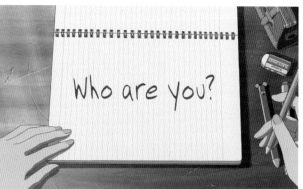

On the way to school, Mitsuha ran into her friends Sayaka Natori and Katsuhiko Teshigawara. They both mentioned she'd been acting funny yesterday, commenting that at least she was herself again today.

After they'd walked for a while, they came upon a group of people listening to Toshiki Miyamizu, the town mayor and Mitsuha's father, who was delivering a campaign speech as part of his bid for reelection.

Then, during a classics lesson in school, Mitsuha noticed something odd. There in her notebook was a message in a handwriting she didn't recognize...

Sayaka and Teshigawara said she'd acted as if she had amnesia the day before. She'd even forgotten where her own desk and locker were.

Sayaka asked her if it could have been due to stress, and Mitsuha groaned.

"I can't stand this town anymore! It's too small and close-knit! I want to graduate and go to Tokyo."

In a classics lecture at school, they discussed the expression *tasokare*—"who goes there?"— as the origin of the word *tasogare*, or "twilight." In Itomori's local dialect, the equivalent word would be *half-light*.

Mitsuha mentioned a strange feeling she had, as if she'd dreamed about living someone else's life. Teshigawara shouted, "I know! That was... your previous life!"

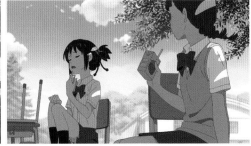

"Well, I do feel like I've been in a strange dream lately..."

"Things must be rough for her."
After Mitsuha went home, Sayaka and Teshigawara thought about their friend. Born into the family that ran Miyamizu Shrine, Mitsuha had duties to perform.

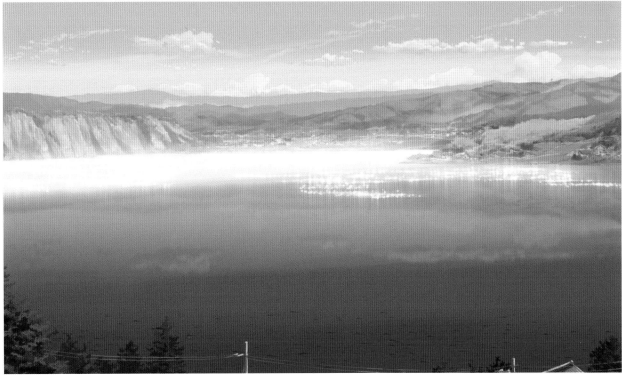

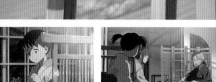

"When you keep twining like that, emotions will eventually start flowing between you and the thread."

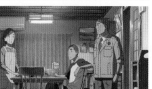

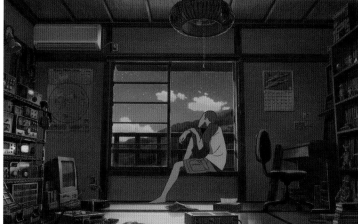

For generations, the Miyamizu family had served at Miyamizu Shrine.

Their father had abandoned the priesthood and left home, so Mitsuha and Yotsuha lived with Hitoha, who was a Shinto priestess, and worked as shrine maidens.

One of their duties was making braided cords, whose patterns held a thousand years of Itomori's history. Mitsuha was braiding a cord that would be used in a certain ceremony.

In the ceremony, as one of Miyamizu Shrine's maidens, she would perform a ritual dance, then make *kuchikami*—"mouth-brewed"—sake, to offer to the body of their shrine's god.

It was a deeply sacred ceremony, but to Mitsuha's teenage eyes, it was downright depressing.

At Teshigawara's house, Mitsuha's father was drinking sake with Teshigawara's father, who worked in the local construction industry. "We both have it rough, don't we?" Teshigawara murmured sarcastically.

 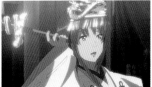

 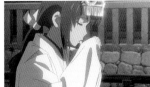

Mitsuha put rice in her mouth, mixed it with her own saliva, slowly dribbled it into a small measuring box, then sealed it with a braided cord. This *kuchikamisake* would be offered to the body of the shrine's god and allowed to ferment naturally.

"It's the oldest sake in the world."

When she realized some of her classmates had seen the ceremony and found it disgusting, Mitsuha felt discouraged. She longed for a life completely different from her own.

"Please make me a handsome Tokyo boy in my next life!"

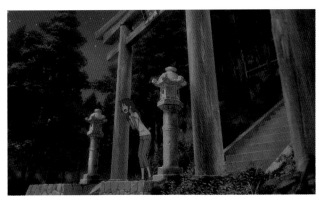 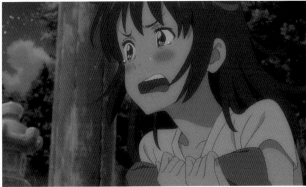

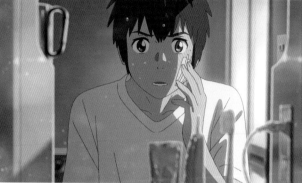

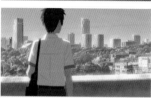

"I'm in Tokyo!"

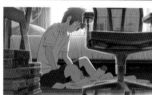

Unused to sleeping in a bed instead of on a futon, Mitsuha was startled by her alarm and went crashing to the floor. As she got dressed, she realized she was in a boy's body and flushed bright-red.

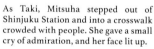

As Taki, Mitsuha stepped out of Shinjuku Station and into a crosswalk crowded with people. She gave a small cry of admiration, and her face lit up.

One morning, Mitsuha, a high school girl living in the rural mountain town of Itomori, woke up in an unfamiliar room.
A boy's school uniform was hanging in front of her, and the small room held all sorts of books.
"...Where am I?" she murmured, still half-asleep. She looked down at herself, and she couldn't help but notice her body had two missing parts and one extra. "Aaaaagh!"
When she looked in the mirror, she saw the face of an unfamiliar boy.
Taki Tachibana's face, to be precise.
This was his room, in central Tokyo.
With no idea what was going on, Mitsuha, in Taki's body, saw Taki's father off, then left the condo to go to school.
And then, just outside the condo, she found the Tokyo cityscape...
Enthralled and exhilarated, Mitsuha went into the city. She got lost on the way, finally reaching Taki's school at lunchtime.
After school, she and some of Taki's friends took a detour to one of the cute cafés she'd always fantasized about.
Assuming it was all a wonderful, vivid dream, Mitsuha decided to enjoy her situation to the fullest.

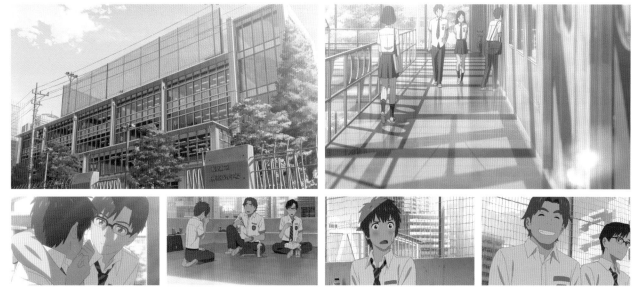

Upon reaching school, Mitsuha had lunch with Taki's friends, Tsukasa Fujii and Shinta Takagi. Although Taki was oddly flustered around them, they made him an improvised sandwich since he'd forgotten his lunch.

Takagi and Tsukasa seemed interested in the café's interior design. As she watched them out of the corner of her eye, Mitsuha did a double take over the cost of the pancakes. Then she got a call from Taki's part-time employer...

"Um...
Where do
I work?"

When a customer falsely accused Taki of sticking a toothpick in his pizza, Ms. Okudera came to the rescue—until the customer slit her skirt with a box cutter.

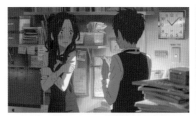

"I like you better today."

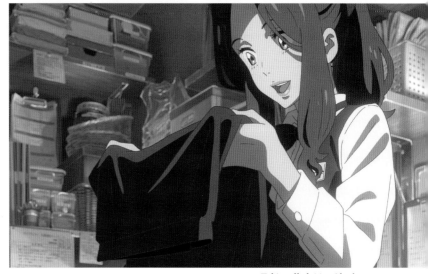

Taki pulled Ms. Okudera to the staff room and told her, "Take off your skirt, please." Ms. Okudera was startled, but she was soon delighted to find Taki had mended the skirt with a cute bit of embroidery.

Still in Taki's body, Mitsuha headed for his part-time job.

Taki worked as a waiter at a fairly popular casual Italian restaurant.

Everything was a first for Mitsuha, though, and she was run off her feet. She made lots of mistakes, and to make matters worse, a malicious customer tried to start trouble with her. She was rescued by Ms. Okudera, a university student who'd been working at the restaurant longer than Taki and was something of an idol among the staff.

Out of spite, the customer slit Ms. Okudera's skirt.

Mitsuha, as Taki, quickly mended it for her, and Ms. Okudera was intrigued by his unusual behavior.

Once she got off work and returned to Taki's condo, Mitsuha found a picture of Ms. Okudera among the photos on Taki's phone, sensed his feelings for her, and smiled.

She couldn't help being impressed by how vivid this dream was.

 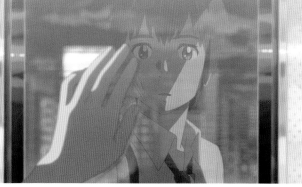

"What a
realistic
dream
if I say so
myself."

Mitsuha made
a new entry in
the diary on
Taki's phone
and recorded
everything
she'd done that
day, including
getting closer to
Ms. Okudera.

"A crush,
maybe?"

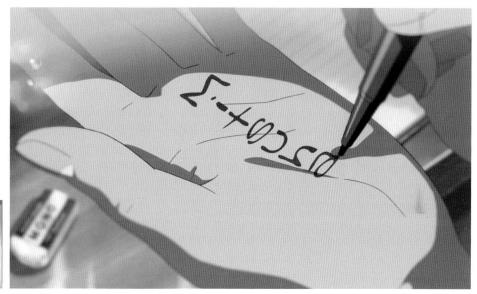

Suddenly remembering the *Who are you?* she'd found in her notebook, Mitsuha wrote her name on Taki's palm.

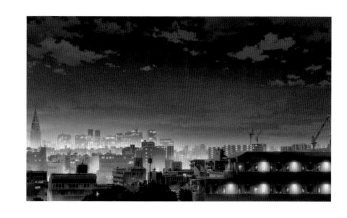

While eating breakfast with his dad, Taki found the entry about going home with Ms. Okudera in his phone diary, and his eyes went wide.

My friends are nice, and I'm a little bit handsome too. Working part-time at the restaurant was a shock at first, but it was really exciting, like something out of a movie! ✦
Thanks to my mistake, I managed to get closer to the super-gorgeous ♥ Okudera-senpai. ♪ On the way home from work, we walked as far as the station together.

All because I'm in touch with my feminine side. 💕

"What is this?"

With a hurried "I have to go to work," Taki left in a rush. "He's acting normal today," Takagi commented as they watched him go. "Yesterday, he was kind of cute," Tsukasa replied.

Taki's coworkers cornered him, accusing him of going home with Ms. Okudera the day before. That was when Ms. Okudera herself arrived and gave Taki a friendly wink.

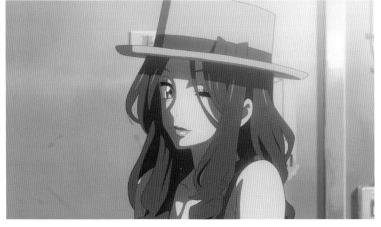

"Let's make this a good one. Right, Taki?"

The next morning, Taki was himself again.
 When he saw the *Mitsuha* written on his left palm and read the journal entry on his phone, he yelled in surprise.
 The way Tsukasa and Takagi reacted to him at school was clearly different from usual, as was the way Ms. Okudera and his coworkers acted around him at work. Something was weird.
 Mitsuha had the same odd feeling.
 When she woke up, there was a message from Taki scrawled on her left arm.
 At school, her classmates were giving her patently strange looks.
 "Well you made quite a scene yesterday."
 Mitsuha was shocked when Sayaka told her what had happened.
 Her classmates had been talking about her behind her back, and Mitsuha had called them out on it, almost picking a fight with them.
 And then Taki and Mitsuha caught on. The two of them were switching places in their dreams, and everything they'd thought was a dream had really happened...

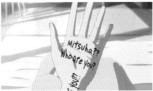

"You're not touching your boobs today."

Mitsuha was aghast, realizing from Yotsuha's comment that she'd been touching her boobs earlier.

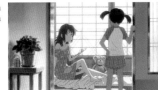

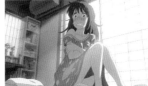

When Taki, as Mitsuha, heard Mitsuha's classmates making fun of her during a conversation about the mayoral election, he gave them a cocky smirk, looked them right in the eye, and kicked over a desk.

"Is this... Could this be...?"

"In our dreams, that guy and I are..."

"In our dreams, that girl and I are..."

"Switching places?"

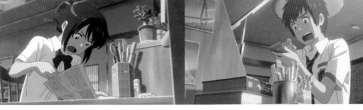

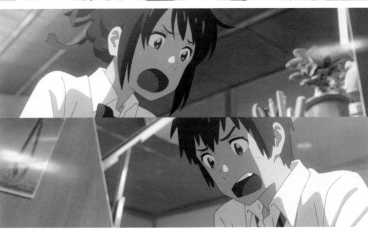

Mitsuha's notebook held notes she didn't recognize. Taki's smartphone had entries about Mitsuha's life in Tokyo. As each realized the other existed, both were stunned.

"I'm beginning to get what's going on. Taki is a boy my age living in Tokyo."

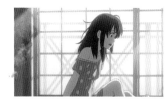

"I switch with Mitsuha at random, a few times a week unexpectedly. Sleep triggers it. The cause is a mystery."

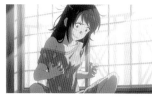

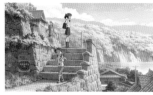

"My memory of the switch is hazy...

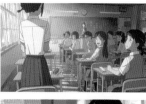

...after I wake up."

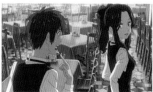

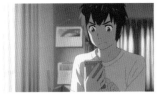

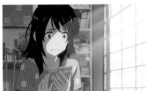

"But we're definitely switching places. It's obvious from the reactions of the people around us. So..."

"So we laid down some rules to protect each other's lifestyles. Things to watch out during the switch and a list of 'don'ts.'"

• Absolutely no baths, ever!!! 🍅
• Do not look at or touch my body!! ⬤
• When you sit, keep your legs together! ⚠
• Don't touch the boys! ✶
• Don't touch the girls, either! ⟳
• ...ever! 🔞

• Don't ...waste my money! ☺
• Don't talk with an accent! ❄
• Don't be late! ❄
• Don't talk like a girl! ✶✶
• Back off Okudera-senpai!
• Don't get cu...

"We also agreed to leave reports in our smart-phones."

"To work together to tide over this mysterious phenomenon."

"But...
That guy!"

"But...
That girl!"

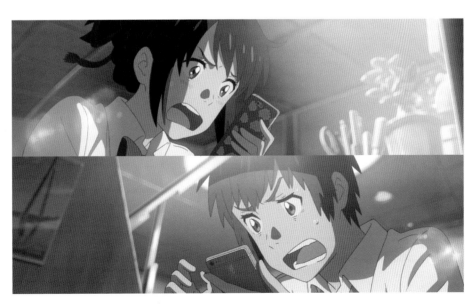

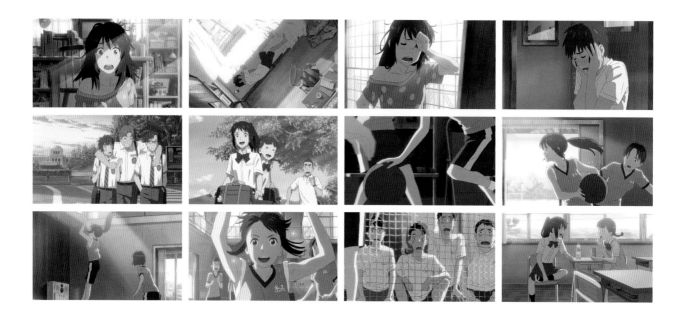

"Guys are staring! Watch the skirt! Come on, this is basic!"

"Stop wasting my money!"

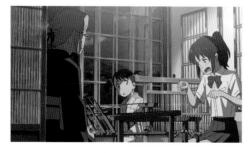

"Braided cords...I can't do this!"

"You work too many shifts!"

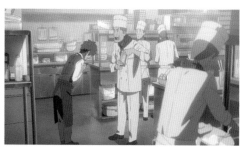

"Grabbed coffee with Ms. Okudera. You two have a good thing going!"

"Taki, why is a girl in love with me?"

"Mitsuha, stop changing my relationships!"

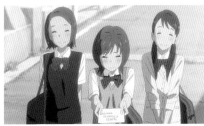

"You're more popular when I'm you."

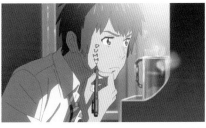

"Don't be full of yourself! Not like YOU have a girlfriend!"

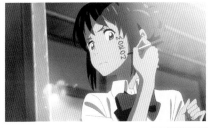

"You don't have a boyfriend!"

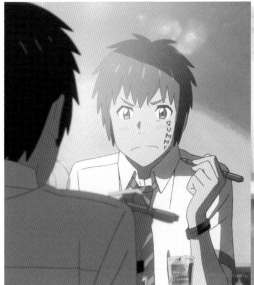

"I..."

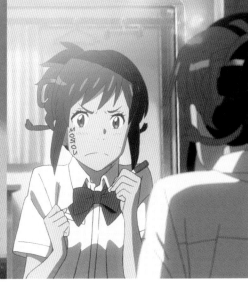

"I..."

"I'm single because I want to be!"

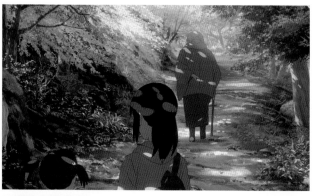

Hitoha described the concept of *musubi*. The local guardian deity was called Musubi, "creator of spirits," she said. Joining threads, connecting people, and the passing of time were all *musubi*, the power of the god. Braided cords were divine acts as well, and they represented the flow of time itself.

"They converge and take shape. They twist, tangle, sometimes unravel, break, then connect again. ***Musubi*** - knotting. That's time."

Taki and Mitsuha switched over and over, living their own life and the other's life by turns.

One day, after they'd settled into this new reality, Taki—as Mitsuha—went with Hitoha and Yotsuha to make an offering to the body of Miyamizu Shrine's god.

The body of the god was at the top of a mountain. The reasons for the proceedings weren't clear, thanks to a long-ago fire that had destroyed the ancient documents, but Hitoha told Mitsuha and Yotsuha that offerings were an important tradition that connected the god and humans to each other.

"In exchange for returning to this world, you must leave behind what is most important to you," Hitoha said. She was referring to the *kuchikamisake* they were offering to the god.

Taki didn't know what was going on, but for Mitsuha's sake, he did as he was told and went into the god's earthly form.

By the time they'd finished making their offering, it was twilight.

"It's twilight—*kataware-doki* already," Yotsuha said.

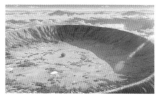

The mountain peak was a geological formation in the shape of a caldera. In its center across a small stream they could see the huge rock and tree that formed the sacred body of Miyamizu Shrine.

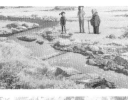 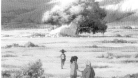

"Beyond this point is *'kakuriyo.'* It means the under-world."

"Half of Mitsuha..."

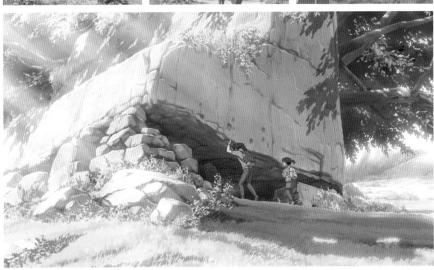

When Hitoha told them that the *kuchikamisake* was "half of you two," Taki gazed down at the "half" of Mitsuha resting in his hands.

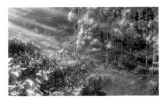

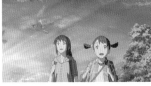

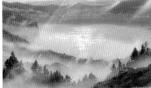

"Oh yeah, maybe I can see the comet." Yotsuha looked up at the sky. Beside her, Hitoha spoke to Mitsuha, but she seemed to be looking through Mitsuha to Taki...

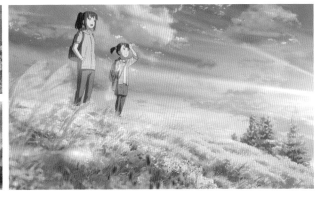

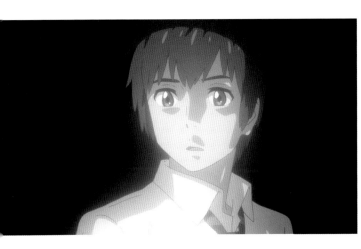

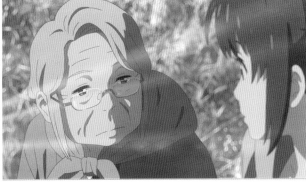

"You're dreaming right now, aren't you?"

"A date?"

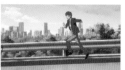

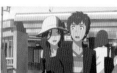

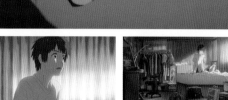

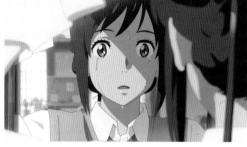

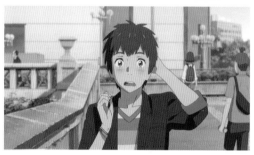

Taki dashed to the meeting spot in front of the station in a panic. Then the mature and lovely Ms. Okudera arrived, and the date began... His heart wouldn't stop pounding for the rest of their time together.

As he followed Mitsuha's plan for the date, Taki was too nervous to keep a conversation going. Mitsuha had left a collection of helpful links on his smartphone, but they seemed more like teasing than anything...

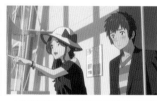

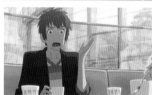

"I don't know what to say..."

When Taki awoke, he was in his own room with tears in his eyes, although he didn't know why.

Then he got a text from Ms. Okudera.

It turned out Mitsuha had made a date with her—without permission—and it was almost time for them to meet up.

With almost no warning, his first date with Ms. Okudera began, but the conversation kept trailing off awkwardly...

However, an exhibit in the museum caught Taki's eye. The display of photos from Hida looked like the town where Mitsuha lived.

The date with Ms. Okudera ended without forming any real connection between them.

On his way home, Taki opened the emergency contact number Mitsuha had left in a note on his smartphone and tried to call her directly.

"You're like a different person today."

During the date, Taki's heart was stolen not by Ms. Okudera, but by the scenery of Hida. Ms. Okudera gazed at him quietly. He didn't seem like the boy who had asked her out.

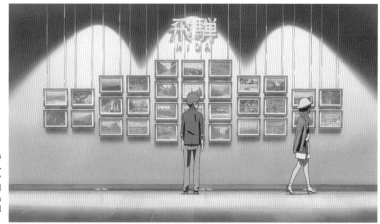

"You used to have a bit of a crush on me, right? But now you like someone else."

When Taki invited her to dinner, Ms. Okudera suggested that they call it a day instead. Sensing that his heart had changed, she picked up on his feelings and told him so, but...

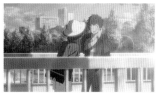 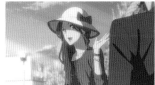

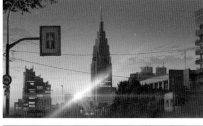

"By the time the date is over, the comet will be visible in the sky."

Mitsuha had written about a comet in the memo on his smartphone. "What is she saying?" Taki muttered. Then, slowly, he called Mitsuha's number...

"Looks kinda funny, I guess?"

Teshigawara was worried for Mitsuha after she sounded so gloomy on the phone. Then Mitsuha appeared with her hair cropped short, and Sayaka and Teshigawara froze up in surprise.

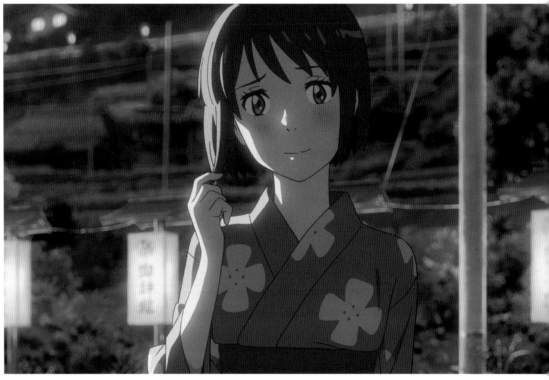

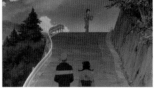

Shaken, Teshigawara whispered to Sayaka that maybe someone had broken their friend's heart. As Mitsuha climbed the slope toward the shrine, she gazed quietly up at the stars.

When Mitsuha's phone started ringing, she answered and heard Teshigawara's voice. She'd skipped school, something she didn't normally do, and he'd called to check up on her.

It was the day of the festival at Miyamizu Shrine, as well as the day when Comet Tiamat would be at its brightest during its thousand-year orbit.

Dressed in a *yukata*, Mitsuha went to meet Sayaka and Teshigawara.

What her friends didn't know was that she'd cropped her hair short...

Sayaka and Teshigawara were startled, but Mitsuha told them she'd just cut it on a whim, and they climbed the hill toward the shrine.

Then they saw the comet, trailing its luminous tail across a beautiful sky full of stars...

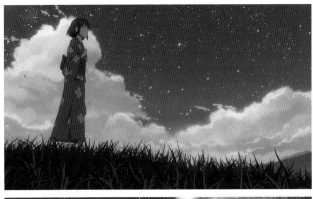
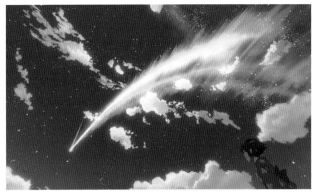

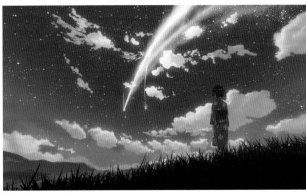

"Oh! Hey! You can see it!"

"...For some reason, after that, Mitsuha and I never switched places again."

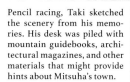

Pencil racing, Taki sketched the scenery from his memories. His desk was piled with mountain guidebooks, architectural magazines, and other materials that might provide hints about Mitsuha's town.

"What the... What are you doing here?"

When Taki explained that the only clue he had about the town was its scenery, Tsukasa and Ms. Okudera were startled. They said they'd come to help him look, but they just played around and weren't very useful...

When he stopped switching with Mitsuha, Taki got concerned about her. Relying on his fading memories, he drew sketch after sketch of the town where she lived.

Finally, he resolved to go see Mitsuha. His only leads were sketches he'd made of places around a town whose name he no longer remembered.

Taki had planned to travel alone, but Tsukasa and Ms. Okudera were waiting for him at Tokyo Station. He'd asked Tsukasa to cover for him with his dad and at work, but Tsukasa had decided to invite Ms. Okudera and come along instead.

When they reached a region that seemed right to Taki, he took out his sketch and went around to the townspeople and asked about it.

There was no promising information to be had. Just when he was starting to think his task was impossible, they finally found someone who recognized the place in Taki's sketch.

But...Mitsuha's town no longer existed.

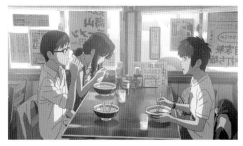

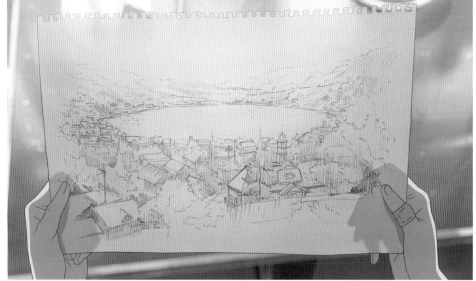

"Itomori was..."

On hearing that the owner of the ramen shop was from Itomori, Taki remembered that "Itomori" was the name of the town. "It's nearby, isn't it?!" he asked, delighted, but...

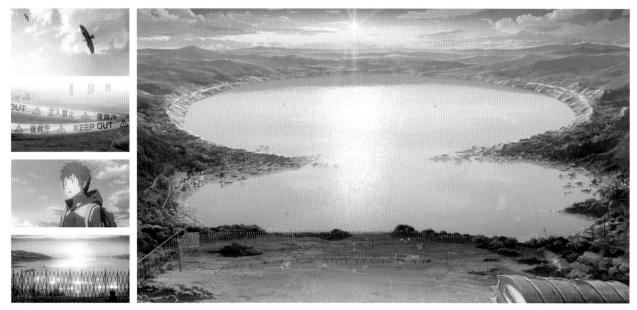

The Itomori that Taki had sketched no longer existed. What he saw was a devastated landscape of collapsed houses, submerged roads, and a train buried in dirt.

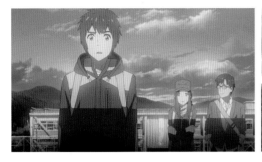

As Taki watched, the journal entries Mitsuha had left on his smartphone turned into gibberish, then disappeared.

"Died? Died 3 years ago?"

"What did I...?"

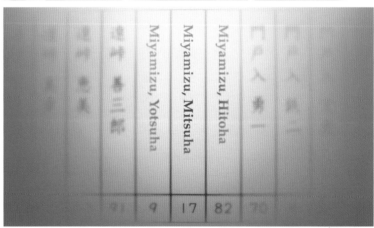

Comet Tiamat, which traveled around the sun in a 1,200-year cycle, had made its closest approach to Earth three years previously. At its perigee, its core had shattered, and a fragment came plunging down. Disaster had struck Itomori.

Ms. Okudera said she liked who Taki had become recently. The things he was saying were strange, but it was probably true that he'd met someone, she thought.

"But I'm sure he met someone and that someone changed him."

Three years ago, the comet's nucleus had split. One part had plunged to Earth as a meteorite, causing a disaster in which several hundred people lost their lives.

That meteorite had fallen on Itomori.

Taki, Tsukasa, and Ms. Okudera went to the library, and as they searched through related books, Taki found Mitsuha Miyamizu's name on a list of the victims.

All the data Mitsuha had left on his smartphone was gone, and Taki began to wonder if everything had been a dream. Maybe he'd recognized the scenery because he'd subconsciously remembered it from the news three years ago. Worse, he even forgot Mitsuha's name...

Just then, Ms. Okudera asked Taki about the braided cord he wore around his wrist, startling him. Then he remembered the body of Miyamizu Shrine's god. "Maybe at that place..."

Early in the morning, Taki left the inn where the three of them had stayed, heading to find it on his own.

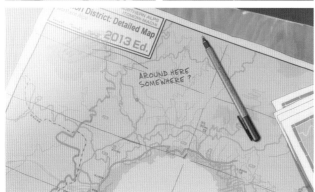

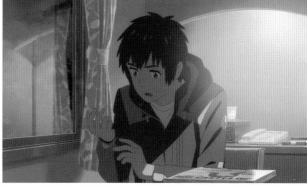

Remembering what Hitoha had told him about braided cords and time, and the body of the god up on top of the mountain, Taki opened a map of old Itomori and searched for the place.

"Your drawing of Itomori...It was good."

Taki got a ride from the owner of the ramen shop. The man complimented him on his sketch and handed him a box lunch without saying much else.

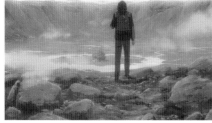

"Half of her..."

When he climbed the mountain, the place was there, just as he'd remembered. It hadn't been a dream. Taki went into the body of the god, then drank Mitsuha's *kuchikamisake*.

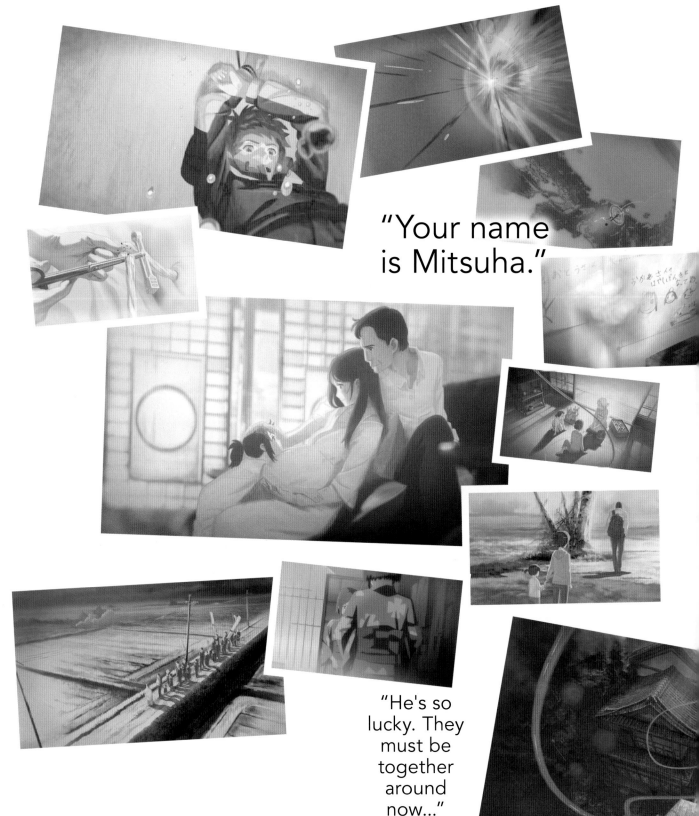

"Your name
is Mitsuha."

"He's so
lucky. They
must be
together
around
now..."

When Taki drank Mitsuha's *kuchikamisake*, he slipped and fell. The impact against the ground dropped him into a beautiful illusion.

It was a vision from the mural of the comet that had been drawn on the ceiling of the god's body. Mitsuha's birth, her growth, Yotsuha's birth, her mother's death, her father's grief. After that, he saw some of Mitsuha's thoughts after she and Taki had begun switching in the dreams. On the day of Taki's date with Ms. Okudera, Mitsuha had also begun to cry without knowing why, as Taki had. Soon after, she went to Tokyo. When she'd returned, she'd asked Hitoha to chop off her hair.

And then the comet bore down on Mitsuha and on Itomori.

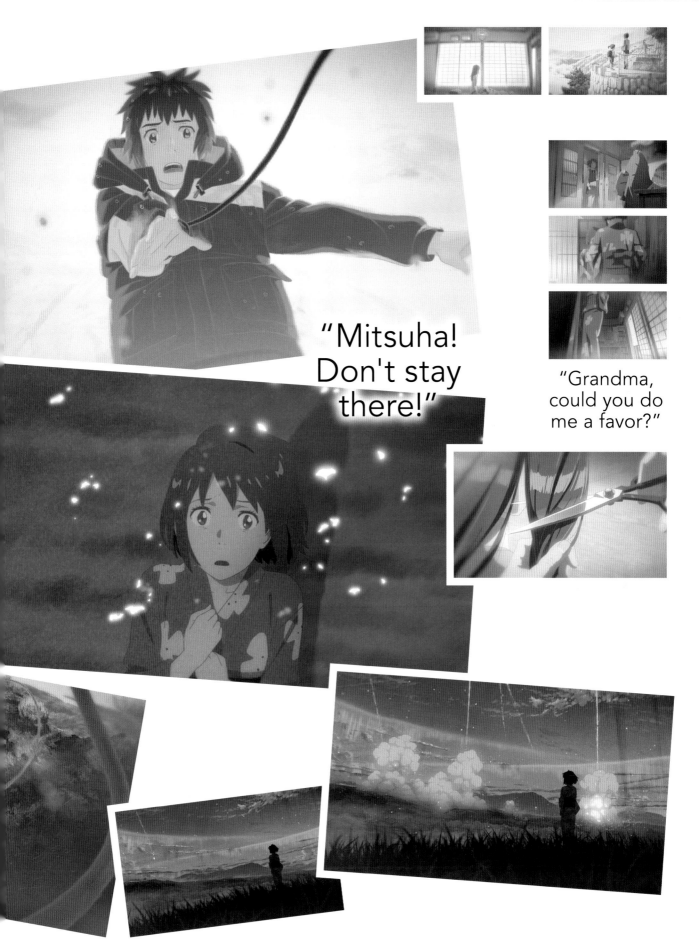

"Mitsuha!
Don't stay
there!"

"Grandma,
could you do
me a favor?"

"I'm Mitsuha! She's still alive!"

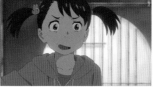
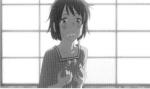

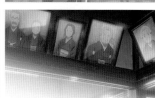

Understanding that Mitsuha wasn't Mitsuha, Hitoha said that she remembered having strange dreams when she was a girl, too.

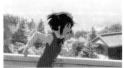
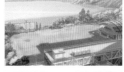
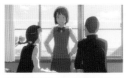
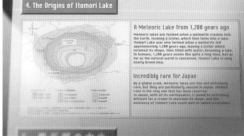

In order to save the town, "Mitsuha" and her friends decided that Sayaka would broadcast an evacuation order, and Teshigawara would use explosives to fake an accidental explosion at the power substation and a wildfire.

"If nothing is done, everyone will die tonight!"

"Madness must be from the Miyamizu side."

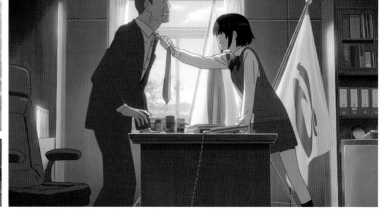

When Mitsuha's father was told about the danger the town was in, he flatly informed his daughter that she was ill. "You son of a...!" Taki shouted. When Taki got up in his face, the man asked him, "Who...Who are you?"

When Taki woke up, the power in the *kuchikamisake* had allowed him to switch with Mitsuha. He was so relieved to find Mitsuha's body was really, physically there that he cried.

It was the day of the autumn festival—the day the comet would fall.

"It's tonight. There's still time."

Taki started to run.

He went to the school, asked Sayaka and Teshigawara for their help, and brainstormed a way to get everyone in the town to evacuate. They developed a ruse involving a wildfire caused by an accidental explosion at the substation, after which they would hijack the disaster alert system and issue an evacuation order from the school's broadcasting room.

In the meantime, Taki went to talk directly to the mayor, Mitsuha's father, and ask him to give the order to evacuate. However, not only did the mayor not believe what his daughter told him, he even asked her who she was.

Taki had failed to convince him. As his anxiety grew, he ran into Yotsuha and heard that Mitsuha had gone to Tokyo the day before. He started thinking hard. Just then, Taki sensed Mitsuha's presence around the mountain that held the god's body...

"Are you there?"

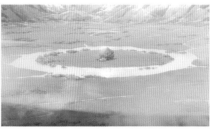

Sensing something from around the god's body, Taki gasped. He borrowed Teshigawara's bike and set off for the mountain.

"The town...is gone."

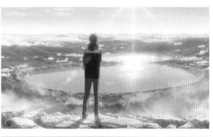

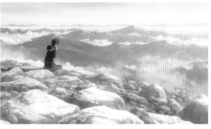

Mitsuha woke to find herself in Taki's body. Wondering why he was so near her home, she left the body of the god only to see that the town of Itomori was no longer there...

"Taki, Taki. Don't you remember me?"

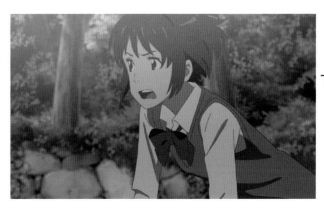

"I'm going to Tokyo."

"There's no way we could meet."

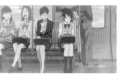

"If we see each other, we'll know."

It was Mitsuha's first trip to Tokyo as herself. She wandered around with no real destination in mind, searching for Taki.

"But... ...one thing is certain."

 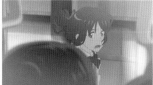

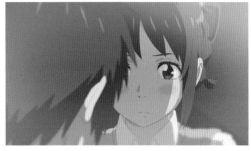 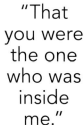

"That you were the one who was inside me."

 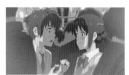

Spotting Taki on a train, Mitsuha boarded. Taki was right in front of her, flipping through vocabulary flash-cards, and she worked up the courage to speak to him. "Don't you remember me?"

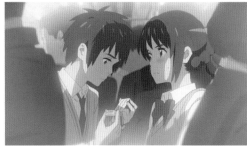

"That I was the one who was inside you."

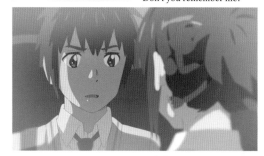

"Who are you?"

That day—the day before the comet fell, the day she thought Taki and Ms. Okudera would be having their date—Mitsuha went to Tokyo.

Unable to contact Taki, she feared she'd never find him, but still she wandered through the city, trusting in the solid connection between herself and Taki.

Then, finally, she spotted him on a train pulling into a station—but when she spoke to him, he didn't seem to remember her at all. Dismayed, Mitsuha tried to get off at the next station.

Just then, Taki asked her name, and as she introduced herself, Mitsuha gave him the braided cord she'd used to tie up her hair.

For Taki, the encounter had happened three years ago, long before he could have known about Mitsuha.

| your name. | VISUAL STORY |

Too embarrassed to stay, Mitsuha tried to leave the train, but Taki called after her.

"What's your name?"

"My name is…"

"…Mitsuha!"

"That time 3 years ago, you came… to see me!"

Taki's heart squeezed at the thought of Mitsuha's feelings when she'd come all the way to Tokyo to see him, and at the fact that the two of them had already met three years ago.

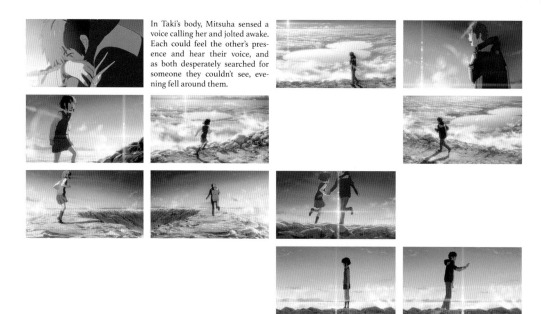

In Taki's body, Mitsuha sensed a voice calling her and jolted awake. Each could feel the other's presence and hear their voice, and as both desperately searched for someone they couldn't see, evening fell around them.

"It's twilight—kataware-doki."

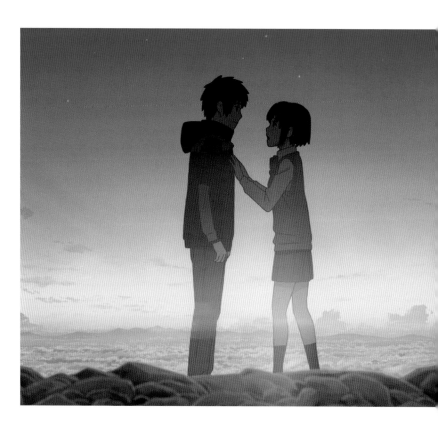

As Taki in Mitsuha's body drew closer to the shrine's holy object, Mitsuha in Taki's body could tell he was there.
"Mitsuha! You're here, aren't you? Inside my body!"
"Taki, where are you?!"
Sensing each other across a span of three years, the two drew closer.
Then half-light arrived.
Each appeared before the other's eyes, and their switched souls and bodies returned to normal.
"Taki. It's really you." Mitsuha sobbed, while Taki smiled at her gently.
"It wasn't easy because you were so far away."
Taki returned to Mitsuha the braided cord she'd given him three years ago. He told her it was her turn to hang on to it.
After Taki filled her in on the strategy to protect Itomori from the comet disaster, Mitsuha summoned her courage to carry out her role in the plan.
Then they decided to write their names on each other's hands before half-light ended.
That way, even after waking up, they'd remember the name of the person who was special to them...

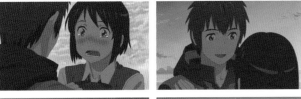 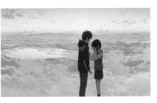

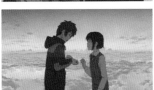

When Mitsuha asked how he'd turned back time, Taki told her he'd drunk her *kuchikamisake*, and her face flushed bright-red. "You idiot! Pervert!"

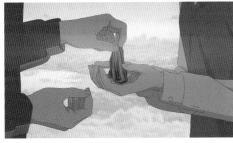 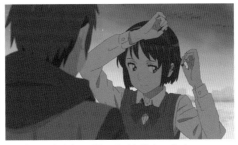

The braided cord that had been around Taki's wrist now accented Mitsuha's hair. "How is this?" she asked, and Taki wasn't sure what to say.

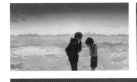 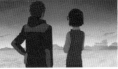

"Someone dear to me. I don't want to forget. I shouldn't forget!"

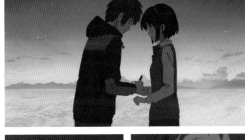

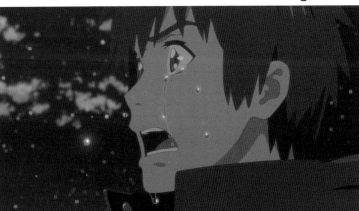

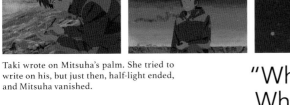

Taki wrote on Mitsuha's palm. She tried to write on his, but just then, half-light ended, and Mitsuha vanished.

"Who? Who? Who? Who?"

"What's your name?"

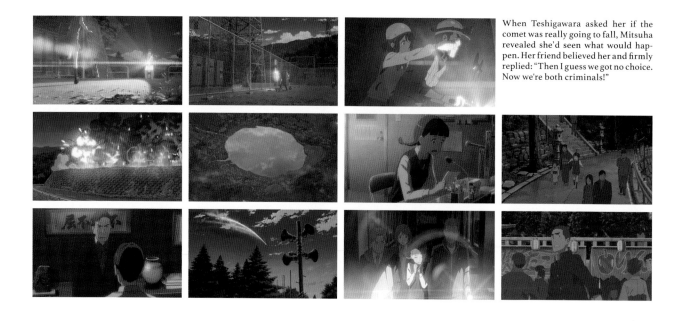

When Teshigawara asked her if the comet was really going to fall, Mitsuha revealed she'd seen what would happen. Her friend believed her and firmly replied: "Then I guess we got no choice. Now we're both criminals!"

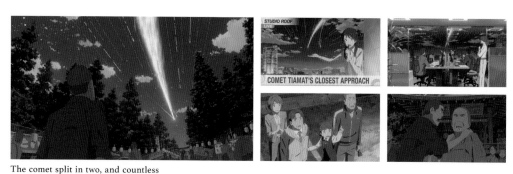

The comet split in two, and countless shooting stars appeared around it. People all over the world were captivated by the magnificent, extraordinary astronomical phenomenon.

STUDIO ROOF

COMET TIAMAT'S CLOSEST APPROACH

"Someone dear to me. I shouldn't forget. I didn't want to forget! Who? Who? Who are you? What's your name?"

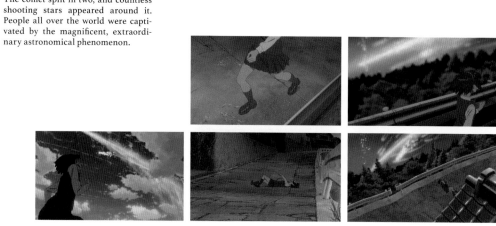

Mitsuha broke into a run. There was nothing for her to do now but what she could.

She met up with Teshigawara, who'd been making preparations for the operation, and they blew up the substation. The power went out, and during the switchover to the emergency power supply, the friends hijacked the disaster alert system. Sayaka sent out an evacuation order, citing a wildfire.

With the power out, the town was pitch-black, and the comet shone in the sky overhead.

Mitsuha and Teshigawara urged the people who'd gathered for the autumn festival to evacuate, but it was clear they wouldn't make it in time. On top of that, Sayaka's frequency hijack had been traced, and her broadcast was cut off.

Mitsuha raced to her father to persuade him to mobilize the fire brigade. But she'd forgotten that precious name in the chaos, and between that and the approaching comet, anxiety and terror threatened to crush her.

But...just when she was about to lose heart, Mitsuha saw the words on her palm from a boy she could never replace.

I love you.

They were precious words from a precious person.

Mitsuha struggled to her feet again.

"I can't remember your name with this..."

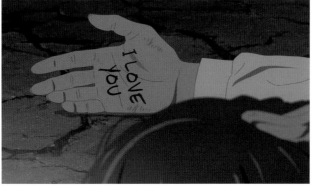

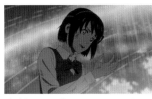

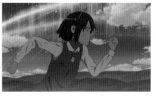

She'd expected to see a name written on her palm, but instead, she found a confession of love. As strength welled up inside her, Mitsuha set off running again.

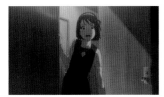

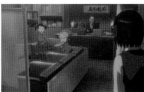

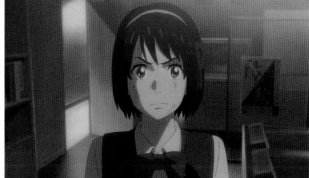

When Mitsuha reached her father, Hitoha and Yotsuha were there, too. Mitsuha walked up to the mayor and confronted him squarely, her eyes filled with the strength of two.

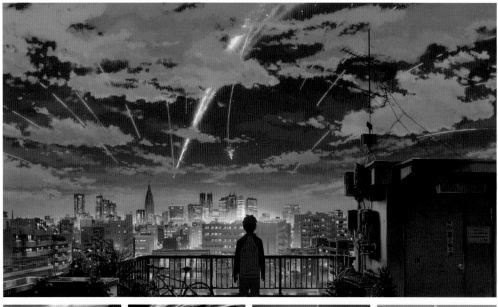

"It was almost as if it were a scene from a dream. Nothing more, nothing less than a beautiful view."

When Taki woke up on the spot where he'd met Mitsuha, he'd forgotten everything. All that was left was the single line Mitsuha had drawn on his right hand. "What am I doing here?"

The comet streamed across the sky, shining and beautiful, while one fragment became a meteorite that plunged to Earth—and struck the town of Itomori.

The meteorite landed squarely on Miyamizu Shrine. The immediate area was destroyed instantly, and the shockwave tore through the surrounding community, land and all.

Several years later, Taki, now a university student, was working hard to find a job alongside his old friends, Tsukasa and Takagi.

He was possessed by a feeling, always searching for something, but there was nothing left in his memories.

...Still, there had been a time when he'd been near-obsessed with the events surrounding a comet.

It had been a night of miracles; half a comet had destroyed an entire town, and yet most of its residents had escaped unscathed.

However, his interest had slowly vanished.

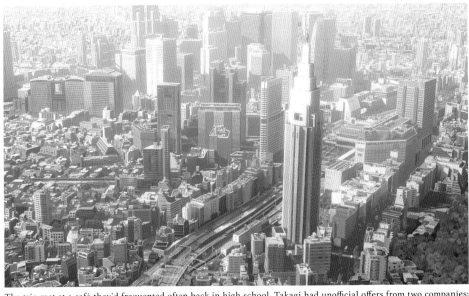

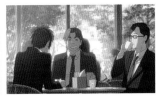

The trio met at a café they'd frequented often back in high school. Takagi had unofficial offers from two companies; Tsukasa had eight. However, Taki hadn't gotten a single one yet.

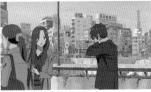

Ms. Okudera called Taki, saying work had brought her to the area. She reminisced about going to Itomori with him and Tsukasa five years ago.

The news reported that, by an incredible coincidence, Itomori had been holding a town-wide evacuation drill on the day of the comet disaster, and most of the townspeople had been outside the devastated area.

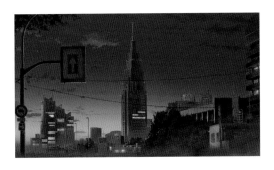

"You
be happy
someday,
too."

As Ms. Okudera waved to Taki, the light glinted off her engagement ring. After she was gone, Taki looked at the palm of his right hand, sensing something was missing.

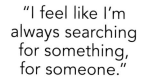

"I feel like I'm always searching for something, for someone."

Listening to a couple talking about bridal fairs, Taki was startled to hear the name *Tesshi*. By the time he turned around, they were gone.

"Why does the scenery of a town that no longer exists wring my heart so?"

Autumn turned to winter, and winter to spring.

Every time Taki came into contact with a certain something, his heart would waver slightly, then return to normal. He became accustomed to the feeling, and eventually, he became a working adult.

That was why he assumed that day would be just like all the others.

He would wake up in the morning, leave the condo, go to his company, work, come home, and sleep.

But the truth was, he'd always had a certain thought in his mind.

Just a little longer—

And without warning, that moment arrived.

Since the comet disaster, many of Itomori's residents had moved into the city. Yotsuha was now a high schooler, and Mitsuha's former high school classmates were working members of society.

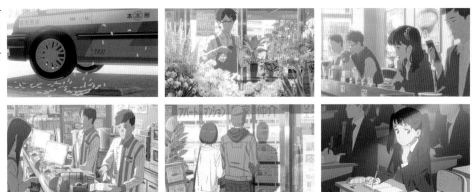

"I was always searching...

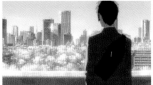

...for some-one!"

Every morning when they looked at their faces in the mirror, both Taki and Mitsuha searched for traces of someone else.

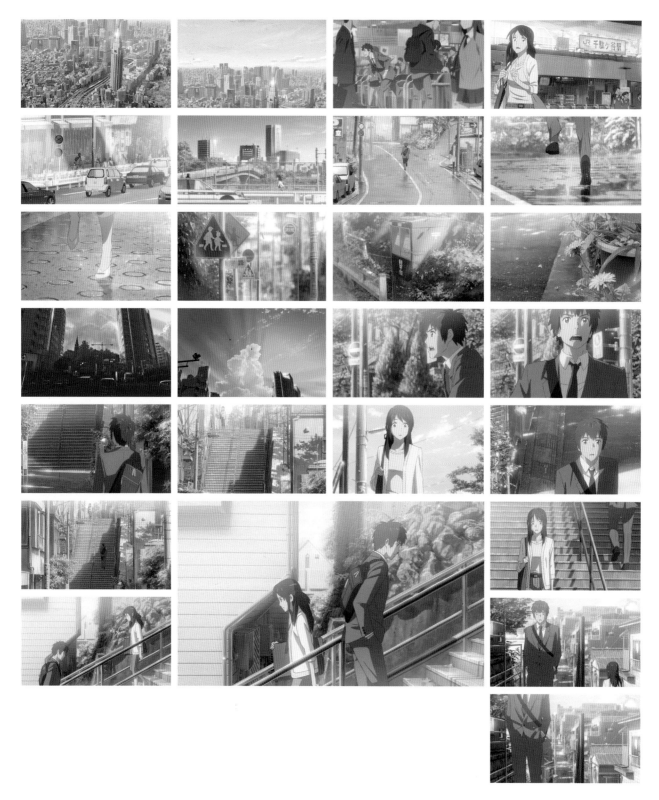

On two trains passing in opposite directions, Taki and Mitsuha saw the one they'd been looking for.
 The moment they caught sight of each other through the glass, their eyes widened.
 When their trains reached their respective stations, both of them dashed out onto the platforms.
 They raced through the streets, searching for that "someone" they'd forgotten but never given up trying to find.
 Then, with nothing to separate them, that someone was standing right in front of them.
 However, neither of them knew what to do. Eyes lowered, they very nearly passed each other by.
 No, that couldn't be enough.
 Taki worked up the courage to speak to her, and Mitsuha waited for him.
 They'd finally met. They'd finally found each other.
 They both asked a question at the exact same time:
 "Your name is...?"

The inability to believe in this miracle joined with a powerful certainty that it was real, and tears spilled over.

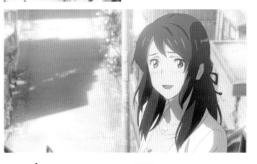

"I thought so, too!"

"...Hey!
Haven't we met?"

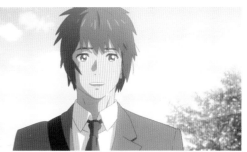

"Your
name
is...?"

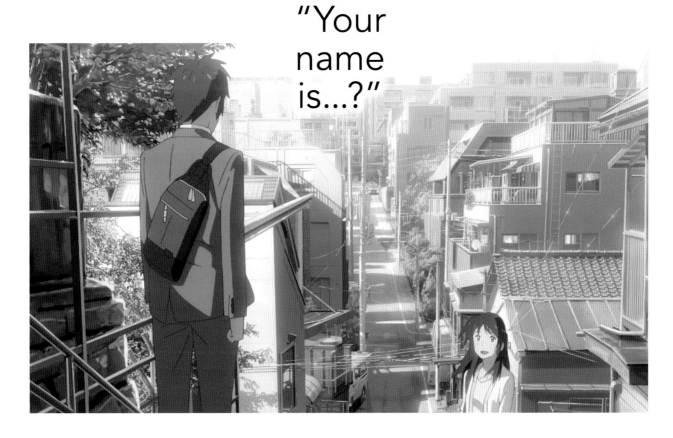

A Fascination with Switching Places
The Subtext of *Torikaebaya*

The classic work *Torikaebaya Monogatari* is the the foundation of all other tales about switching places. Director Shinkai says that he came into contact with a variety of *Torikaebaya* stories in the course of making *your name.* Here, we'll take a look at several works on that theme that he used as references.
(Text: Mizuo Watanabe)

Torikaebaya Monogatari
(The Changelings)

Editor: Hiroko Suzuki
Kadokawa Sofia Bunko

Boku wa Mari no Naka
(Inside Mari)

Shuzo Oshimi
Action Comics Futabasha

Ranma 1/2

Rumiko Takahashi
Shogakukan

"The Safe-Deposit Box" in
"Oceanic" and Other Stories
(Japanese Edition)

Greg Egan
Japanese edition translated and
edited by Makoto Yamagishi
Hayakawa Bunko SF

The classic *Torikaebaya Monogatari* is practically synonymous with the idea of switching places, but in that story, a man and a woman are merely raised as the opposite sex rather than physically switching bodies.

This time around, Director Shinkai used the word *Torikaebaya* in his initial project proposal. He says he referred to a variety of books and films in the process of creating his story about a boy and girl who switch places, and while developing his idea, he decided not to make it a tale about gender differences.

"These days, it's normal to see girls who are 'boyish' and boys who are 'feminine,' so I think it would be hard to deliver a *Torikaebaya* story relying on the differences between the genders to pull an audience in. *Inside Mari* (Shuzo Oshimi) is a story in which a dull college student becomes a high school girl and has the chance to see what her life is like, and I thought a hook of that nature would be more relatable. As a matter of fact, I thought it would be better if the key points of interest came from this inherently intriguing kind of switch, where one person becomes another (as in *Ranma 1/2* [Rumiko Takahashi]), and from the way the ones switching get to know each other by experiencing and seeing through another's body." (Conversation with Director Shinkai)

Director Shinkai also referred to "The Safe-Deposit Box" by novelist Greg Egan, a short story about an individual who wakes up as a different person every morning. He saw some commonalities between that story and the South Korean film *The Beauty Inside*, so he went to see that as well. We hope this background will enhance your enjoyment of the film and that you'll have fun with all different types of "switching."

SPECIAL CROSS TALKS

Packed with content, including interviews with the director, cast, and staff,
cross talks, and more.
Hear about the appeal of the film from all angles!

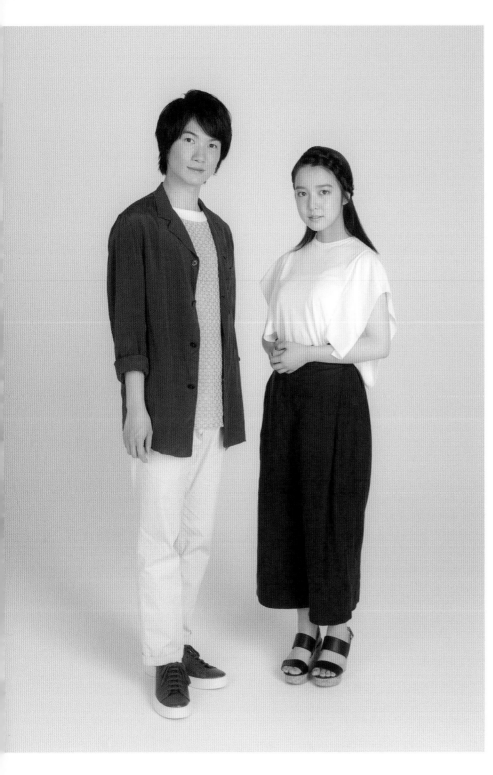

While Ryunosuke Kamiki and Mone Kamishiraishi played Taki and Mitsuha, they also played Mitsuha and Taki; each actor had two roles as a boy and girl who switch places in their dreams. Although this was the pair's first time working together, they warmed up to each other during the recording process, just like Taki and Mitsuha themselves, and developed a relationship that makes them laugh nonstop whenever they talk about it. Their first meeting was at the recording session for the film's teaser. As they looked back over the experience, they also spoke with us about their roles and about the film.

Kamiki: We first met at the recording for a *your name.* teaser. Since we'd never met before, it was like, "...Hi." We were both very timid.

Kamishiraishi: I'd been watching Kamiki's films for ages, so what I was thinking was "Kamiki actually exists!" I was so nervous. (laughs)

Kamiki: I really do exist! I do a lot of my existing over there. (laughs) At the time, when I heard Kamishiraishi speak, I thought, "That's the voice of a Shinkai film family member." It was clear as a bell, a perfect match for Director Shinkai's world. It struck me as the voice of a heroine. I wasn't sure I'd be able to bring one of Director Shinkai's films to life with my own voice, so frankly, I was freaking out a tiny bit.

Kamishiraishi: Oh no, no! I was the one freaking out. When I heard Kamiki's voice, it just grabbed my heart right away. I was like, "I knew it—he's amazing. He really is a genius."

Kamiki: I'm not a genius at anything. (laughs)

Kamishiraishi: Kamiki's regular voice and his voice when he's acting are completely different. And he can just slip into character and see the whole world through their eyes. I remember thinking, "His ability to focus really is something special." I'd get lost listening to his voice and end up accidentally leaving pauses before I said my next line. I was constantly overwhelmed by his voice and by the visuals.

[Taki Tachibana]

[Mitsuha Miyamizu]

Ryunosuke Kamiki ✕ Mone Kamishiraishi
Interview

your name. as seen through the eyes of Ryunosuke Kamiki and Mone Kamishiraishi, who lent their voices to main characters Taki and Mitsuha. Their take is youthful and fresh, yet down-to-earth and practical. What do they have to say about each other's voice and performance, and the film itself?

Interview/Write-up: Mizuo Watanabe Photography: Mikio Shuto

Kamiki: In our spare moments, we'd talk to each other about how good the movie is.

Kamishiraishi: Practically the first conversation we had was "I want to see this soon." "It opens in August, huh? That's still a ways off." (laughs)

Kamiki: We were like, "I'm absolutely buying the first-run, limited-edition DVD. Are we seriously doing the voices for this?!" (laughs)

Kamishiraishi: We'd start staring in spite of ourselves, even though we were the ones performing in it. We did have lots of little conversations like that, didn't we? (laughs) They chose me for the role of Mitsuha through an audition, and it didn't really sink in that they were letting me play Mitsuha until we'd started recording for the teaser. The director was giving me notes, Kamiki was next to the booth, and I was shivering, thinking, "It's really starting—something absolutely *incredible* is starting." Then more time passed, and we began recording for the actual film. We were nervous at first, weren't we?

Kamiki: I was. And I started by recording for Mitsuha-as-Taki, too, so there was a ton of pressure. I got to chat with the other voice actors when I had some free time, and there was a moment when I stopped and realized I hadn't done any acting in my natural vocal range yet. (laughs) Even when I was playing Mitsuha, the vocal cords were still Taki's, so I didn't think I could go too high. No matter what, I had to make sure to keep some of Taki's qualities in it. On top of that, I had to create a distinction between the switched and unswitched roles as well, so it was hard.

Kamishiraishi: You made them very distinct! I thought it was incredible.

Kamiki: Oh, good! That's the sort of acting you can only do for an animated film, and it was a fun experience. In retrospect, I'm glad they let me start with Mitsuha-as-Taki. That made it easier to strike a balance with Taki's natural voice. Plus, I started with some mildly embarrassing scenes, so I think it got rid of all my tension at once. (laughs)

Kamishiraishi: My first lines were Taki-as-Mitsuha, too, but my experience was the total opposite of Kamiki's. At first, I was just a bundle of nerves. Voice-acting jobs are scary enough for me as it is, and then not only was I talking like a guy right at the start of recording, but also it was the very beginning of the movie, so I really didn't know what to do. Acting while the personalities were switched was a challenge, as you'd expect, but it was also a whole lot of fun as a completely new experience. It was an unknown world for me, so when I saw high school guys on the street, I paid attention to how they carried themselves and how they talked. (laughs) I also watched Kamiki in his sessions. Becoming Taki also means becoming Kamiki, so I observed his performances to research how he spoke.

Kamiki: Kamishiraishi asked me if I could recommend any movies where I'd played a manly role that might make a useful reference, and I worried over it for maybe two days. (laughs) I've had lots of specialized roles lately, such as fighting in the Bakumatsu period (*Rurouni Kenshin: Kyoto Inferno/The Legend Ends*) and stopping time and carrying out covert operations (*SPEC: Metropolitan Police Public Safety Department Section 5 – Unidentified Crime Unit Case Files*), so I had to think. (laughs) In the end, I recommended *Eleven of Us!*

Kamishiraishi: That's right. I'd watched *Eleven of Us!* back when it was originally airing, and I'd enjoyed it then, too. This time, though, I paid particular attention to the masculine qualities of Kamiki's acting. I was especially worried about how to act when I yelled, so I studied that.

Kamiki: When I played Mitsuha-as-Taki, I tried to express her in ways I thought Kamishiraishi would if she were reading those lines. I also tried to stay conscious of tone and delivery choices that would probably strike guys as "cute," and that girls could relate to.

Kamishiraishi: On that note, I used the way Kamiki played Mitsuha as a reference sometimes, too. I listened to the way he talked, and I learned from that. Even when I was playing a girl myself, he helped me out a lot. (laughs)

What sort of people are Taki and Mitsuha, and what is their appeal?

Kamishiraishi: Taki is just incredibly cool. There were all sorts of anime magazines lying around the studio, and I looked at them and thought, "Taki's cooler than any of these protagonists!" (laughs) I may have caught some of Mitsuha's feelings for Taki. He has a solid, grounded core, and he's quick-witted and clever. I thought it was amazing that he remembered scenery he'd only seen once and that he was able to find his way to it. He's somebody you can count on, and I think he's really wonderful.

Kamiki: Seriously? But Mitsuha treated him like a guy who'd never get a girlfriend. (laughs)

Kamishiraishi: He really isn't good with girls, is he? (laughs) But I think that's also part of his charm. You could say he's consistent, in a way. That's wonderful, too.

Kamiki: He's a consistent, clumsy, stubborn guy, isn't he? He feels like a very contemporary city kid—a bit cool and blunt toward everyone,

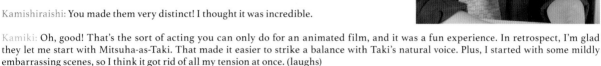

"It's cute when Mitsuha's dishing up rice for herself, and she murmurs, 'Is that too much…?'" (laughs) (Ryunosuke Kamiki)

| RYUNOSUKE KAMIKI |

Born May 19, 1993, in Saitama Prefecture. Debuted in the 1999 drama *Good News* (TBS). Won the 29th Japan Academy Newcomer of the Year Prize for the film *The Great Youkai War* (2005). He's recently appeared in *The Kirishima Thing* (2012), *Rurouni Kenshin: Kyoto Inferno/The Legend Ends* (2014), *As the Gods Will* (2014), *Bakuman* (2015), *The Sun* (2016), *Too Young to Die* (2016), and more. *March Comes in Like a Lion* (Parts 1 and 2), in which he plays the lead, is scheduled to be released in 2017.

even his friends. He's also very realistic and modern, not like your average animated character, and I wanted the vocal performance to come across more like what you'd find in a live-action film. It would make him feel a little subdued for an anime, but particularly when he's talking to Tsukasa and Takagi, I wanted him to sound brusque.

Kamishiraishi: That was the part that really screamed "Taki!"

Kamiki: Mitsuha is a very cute girl. She guileless and takes things at face value, and all of her emotions seem really pronounced. The way she smiles while she's crying is cute, too. I think she's really very feminine. She's got a girlish sweetness about her.

Kamishiraishi: As I acted out the role, I thought that maybe Mitsuha was a portrait of the type of woman the director likes. To me, Mitsuha seems a little spacey. But that's what's cute about her, I suppose. (laughs) She's the oldest daughter in an incredibly venerable family, so while she's practical and smart, she's also holding a lot of complicated feelings inside. But she also has this rather spacey side that makes you worry for her. According to the director, Mitsuha is the lowest member in the Miyamizu family pecking order. Her little sister, Yotsuha, is higher. (laughs) Mitsuha's simplicity and transparency reminded me a little of myself, which made me like her!

A fantasy, yet real: truly in the space between dreams and reality

With all manner of things on their minds, the pair worked to deliver their best performances. While they were recording, they say they were really looking forward to the finished movie. When they did see the completed film, what impression did *your name.* make on them?

Kamiki: The word "poignant" sums it up perfectly. The scenes I hadn't seen before were thrilling, and there's a melancholy that runs through the whole film. It has the elements you'd expect to find in an animated fantasy, but the landscapes and emotions depicted in it are very real. The style truly does hover somewhere between dreams and reality. I think it's an amazing film. Also, the RADWIMPS music is fantastic. The moment the music started to play during the opening, I got chills. And anxiety. "Uh-oh," I thought. There was so much power there, and I was afraid my acting might fall short. However, when Director Shinkai put it all together, he struck a very good balance. And you can't forget the power in the visuals and the story as well. To me, the whole thing was a perfect chemical reaction.

Kamishiraishi: It really got to me, too. When I finished watching it, the film stayed with me for a long, long time. I couldn't help worrying about my own voice at first, and I didn't let myself get sucked in, but as we got into the second half, I really couldn't have that disconnect anymore. I could tell something amazing was in motion in front of me, and even after it was over, I knew we'd made something incredible. I can say with certainty that I had the privilege of participating in a monumental work that will go down in history. My heart's still pounding, and the thought makes me stand taller.

The film's perspective is Taki as seen by Mitsuha and Mitsuha as seen by Taki. When they saw the finished film, what drew Kamiki to Kamishiraishi's Mitsuha, and what appealed to Mitsuha about Kamiki's Taki? We asked both of them about their favorite parts of each other's scenes.

Kamishiraishi: Practically everything, really, but I particularly love the kindness in his voice when they meet at half-light and he says, "Mitsuha." And when he's Mitsuha on the inside and finds the picture of Ms. Okudera on the phone, the "Oh, it's her! Maybe he's got an unrequited crush..." line is really adorable. I got to watch Kamiki from behind as he recorded, and when I heard that line, I was like, "Wh-what is this?! My heart's skipping all over the place!!" Even in the finished film, he's seriously adorable. It redefined "cute" for me.

Kamiki: Thank you very much. I have mixed feelings about that. (laughs) As far as scenes I like for Mitsuha, one is where she's dishing up rice for herself, and she murmurs, "Is that too much...?" That was cute. You think, "You obviously want it, so go ahead and eat it!" but she's concerned about it. (laughs)

Kamishiraishi: It's very girlish, isn't it? (laughs)

Kamiki: Also, when she's Taki on the inside, and she hears people gossiping about her behind her back at school, the part where she asks Saya-chin (Sayaka), "That's me they're talking about, right?" That was way cool. I remember thinking, "She really did turn into Taki."

Kamishiraishi: I was incredibly nervous about that part, so that's wonderful to hear. In terms of their scenes together, the dialoguing-with-monologues bit was fun. That might actually be my very favorite scene.

Kamiki: You mean the one where they're like, "That girl!" and "That guy!"? Even when we were acting that out, I thought the tempo was really good. I could feel the story moving along at a fast clip and the energy of the film, so that was fun. They're monologues belonging to the individual characters, but they turn into a dialogue. It's an entertaining concept.

Kamishiraishi: As a viewer, I thought, "How great would it be if Taki and Mitsuha were actually able to get up in each other's face and say this?" They're arguing, but it's also fun because they're so compatible. I wished they could have an exchange like this in person. I agree it's also a really terrific scene.

| SPECIAL CROSS TALKS |

The ethereal beauty of that sky and the theme of "distance"

Kamiki was already a big fan of Shinkai's films, so much so that his love for them and insights about them managed to startle Shinkai himself. Is Kamiki universally acknowledged as the member of the entertainment industry with the most encyclopedic knowledge about Makoto Shinkai? What is it about Shinkai's films that resonates with the hearts of their audiences? What happens if we have Kamiki give Kamishiraishi, a newcomer to Shinkai's films, a lecture on their magnificence?!

Kamishiraishi: Yes, please! (laughs)

Kamiki: Leave it to me.

(laughs) The first point is the beauty of the sky. The sky he draws isn't bright blue; it's a fantastical sky with a faint green tinge, and it changes to suit the scenes and the characters' emotions. And it's not just the sky; the landscapes are breathtaking, and the sounds of nature come through vividly in all his films. Some of the stories are set in real places, so when you visit those places, you immediately think of the movie. That's another part of the appeal, the way you can layer them over reality.

Kamishiraishi: The scenes from everyday life are more beautiful than the real world, aren't they?

Kamiki: The second point is a common theme in each movie: distance. This movie is no exception. The distance between hearts, physical distance, the distance between a fast-paced lifestyle and a slower one—these are illustrated in every movie. There's always something that symbolizes that distance, like the cell phone in *Voices of a Distant Star* or the footprints in *5 Centimeters Per Second*. In *Children Who Chase Lost Voices*, it comes through very clearly in the depictions of the aboveground world and the underworld, the living and the dead. Although it's unclear whether the director is intentionally incorporating "distance" as a theme, or whether he makes works like that instinctively—that's something I'd like to ask him about later on, actually (laughs)—I think it's a definite common thread.

Kamishiraishi: Wow!

Kamiki: Another thing is the way he lets conclusions play out and linger. He doesn't show all the answers. They make you think about how things might develop from this point on. *your name.* also makes you think about the kind of distance that separates Taki and Mitsuha, and how they'll move forward. I think it's really fascinating that the story continues even though the film is over. There is no end; in fact, it's just the beginning. It makes the story itself feel like a prologue for that beginning. Director Shinkai really is an expert!

Kamishiraishi: You're the expert, Kamiki! You could probably get a doctorate in Makoto Shinkai-ology. (laughs) I also think everything you've just described is part of the appeal, but what draws me in are the monologues. The unique choice of words. He'll use many words together that are rather poetic, but they aren't found in other films or used very much, even though they are very familiar. It feels as though they express the director's two-sided style: the way he makes realistic movies while working in fantasy elements. Professor! Is the appeal I'm sensing really there? (laughs)

Kamiki: It's there! (laughs) The lines also make excellent use of pauses. For example, in *The Garden of Words*, there's the "..." in Takao's "That's... what I think now." You wonder why he left a space there.

Kamishiraishi: There are pauses like that in this movie as well, and they do seem very significant.

Kamiki: When you're listening to them, it feels a bit odd but not unpleasant. Do they imply some additional nuances, or are they Director Shinkai's idea of a good rhythm?

Kamishiraishi: That's true. It really is amazing. And when you're talking about the director, you're really amazing, too, Kamiki. (laughs)

MONE KAMISHIRAISHI

Born January 27, 1998, in Kagoshima Prefecture. In 2011, she won the Special Judges' Prize at the Toho Cinderella audition and made her acting debut in *Princess Go* (2011/NHK). For *Lady Maiko* (2014), she won the role of the protagonist, Haruko, in an audition with eight hundred applicants. For the same film, she won the Yamaji Fumiko Film Award's 26th Newcomer Actress Award and the 38th Japan Academy Newcomer of the Year Prize. As a voice actress, she appeared in *Wolf Children*. Her most recent performances include the films *Chihayafuru First Half/Second Half* and *Drowning Love* (scheduled for release on November 5).

That special something in Kamiki's voice: It's cute even when he's playing a girl

Ryunosuke Kamiki's first encounter with Shinkai was *5 Centimeters Per Second*, which was recommended to him by a friend in high school. Since then, he's become a big Makoto Shinkai fan, to the extent that he's seen that particular film over thirty times and makes "pilgrimages" to the places where the movies are set. As protagonist Taki Tachibana in *your name.*, he had the chance to act in one of the Shinkai movies he idolizes. On the other hand, Kamiki got the job because Shinkai fell head over heels for his voice. The appeal of Shinkai films, the appeal of a voice, and the appeal of *your name.*: These talents tell us all about what they saw and sensed in the other.

Kamiki: Personally, I already loved Director Shinkai's films, so I wasn't sure whether my voice would actually work for the character or the film. Was it really okay?

Shinkai: It was absolutely fantastic. "Fantastic" is the only word for it. (laughs) There's something so special about Kamiki's voice that you have to wonder how someone would have to develop to end up with a voice like that. You can manage and change your body, you know, but you can't manage and mold your voice. I think a person's whole body ultimately bears fruit in the form of their voice, and Kamiki's is truly special.

Kamiki: I'm very happy to hear that.

Shinkai: It's cute, but it's also masculine, and it's mature with a gentleness underneath. In that sense, I think the Taki who's switched with Mitsuha is perfect. When he's playing Mitsuha, he really is cute. (laughs) He's able to show that he's a girl using vocal nuances alone. I wonder if that love of animated films means he's had a strong interest in voice acting for quite a long time.

Kamiki: I've always liked sound. Voices and music, things like that.

Shinkai: Maybe your voice is the result of that attraction to sound.

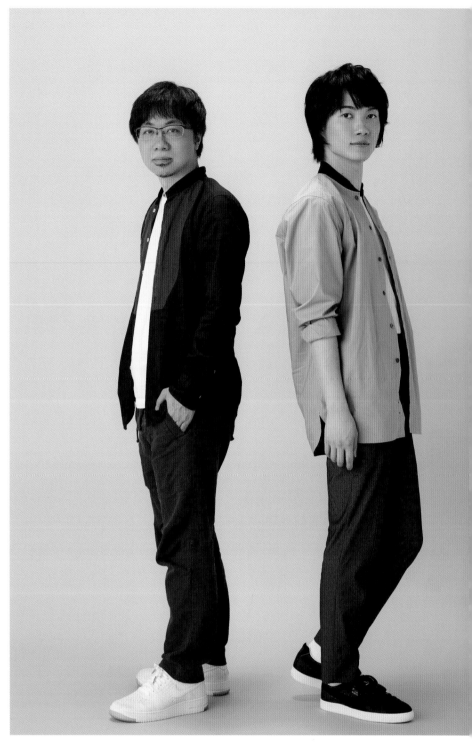

[Director]
[Taki Tachibana]

Makoto Shinkai ✕ Ryunosuke Kamiki
Interview

As production on the movie wraps up, what did Director Makoto Shinkai and Ryunosuke Kamiki, who plays protagonist Taki Tachibana, discover in each other's work and in the animated film *your name.*?
(Interview/Write-up: Mizuo Watanabe Photography: Yuji Hongo)

Kamiki: Director Shinkai's voice is terrific, too, though. We were given a video storyboard to use as a guide, and he had done the voices for all the characters. Problem is, his voice pulled me right into the story, so I couldn't check my lines. I'd suddenly realize I'd forgotten to turn the page of my script. (laughs)

Shinkai: That was more of a humble request: "I'd like you to make something to this effect, so please help me out." It really is just a guide, not even an example. I wanted to at least put the emotions in when I recorded the voices.

Kamiki: You have a terrific voice, and since you were acting out the script yourself, it was clear which parts of the lines you wanted us to give special meaning.

Shinkai: All of you picked up on that perfectly and turned it into something even better, so I'm full of gratitude to you. It's true of the static storyboard as well. I can see the visuals I want, but I can't be the only one who has those pictures in mind, and that's why we have a storyboard that captures their essence. It's the same with voices. There is a certain feel that I want, but of course I can't express it myself. However, I do try to include something like a seed of it to convey roughly what I'm looking for. This time, I feel as though others picked up on that essence and took it to some wonderful places, with regard to both the voices and the storyboard.

Monologues that were spot-on, and acting far more dynamic than anticipated

Kamiki: As you'd expect, what worried me the most were the monologues. Unique monologues are a hallmark of Director Shinkai's films, so I gave them everything I had. (laughs) *5 Centimeters* was the first film of yours I saw, and it's also my favorite. It left a strong impression on me, so the monologue by Kenji Mizuhashi (who voiced Takaki, the protagonist) kept coming to mind. Mizuhashi seems to have a more subdued manner of expression, so I thought about how to give such a fragile-seeming performance. *your name.* also seems incredibly vivid, so I thought about all sorts of things, such as how much of my own color I should add to Taki's character, and what tone I should use when acting as him.

Shinkai: Well, I thought you stuck very close to the image I'd had in mind. The initial "I'm always looking for something, for someone" monologue came out just the way I'd hoped it would.

Kamiki: That's good to hear.

Shinkai: Conversely, during the parts where the characters were actually physically moving, the acting came out well in ways that were entirely different from what I'd anticipated. For example, take the part during Taki's date with Ms. Okudera where she tells him, "There's someone else you like, isn't there?" and he responds, "N-no, there isn't!" The emotion Kamiki brought to the line created a tone I hadn't even imagined. The way he reads that "N-no, there isn't!" makes you think, "Uh, no, there really is, isn't there?!" (laughs) It's patently boyish and brusque. There's strength in it, too, but it's a total lie. The part where he and Mitsuha meet at half-light was brilliant as well. That laughter was so good. It made me think, "I like guys who laugh like that."

Kamiki: That part was a lot of fun to record as well.

Shinkai: I got a very strong sense of the emotions layered over that bit, and the emotions themselves weren't what I had anticipated. They made Taki's lines even more effective. The part where Mitsuha calls him out and he apologizes with that hasty "Sorry!" is good, too. He gave us several versions for that part, but the best of the bunch was the one where he doesn't really sound sorry at all. That "Sorry!" makes you think the same thing Mitsuha says: "You're such a..." It was funny. There was something I wanted to ask out of personal curiosity, too: Kamiki, what's the most interesting part about voice-acting jobs as far as you're concerned, and what's the hardest part?

Kamiki: The hardest part is vocal energy: How much will work for the film, and what will suit the character? That's a new struggle every time, and it was something I had to research. For this film, what concerned me the most was whispering. I was constantly asking myself, "How can I whisper without actually using my vocal cords?" (laughs) I think whispering is a feature of Director Shinkai's films as well, so I had to be careful not to vocalize too much, to make the whisper nearly fade away, and yet I couldn't lose Taki's strong will, either. I really tried to stay aware of the whisper Taki needed to have.

"Kamiki's voice may be the result of his attraction to animation and sound." (Makoto Shinkai)

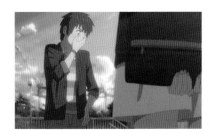
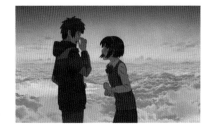

| MAKOTO SHINKAI × RYUNOSUKE KAMIKI |

55

Shinkai: It's possible to make the vocal cords vibrate without using all of your breath, and I think I like a sound that's weaker than normal speech. Plus, whispers make up part of the film's style. During auditions, I often ask people to give me a line in more of a whisper, and they do. However, Kamiki did it in the tone I wanted right from the beginning. It was so instantly perfect that I wondered if he'd come up with it beforehand based on the quirks in my films. It may be partly because he likes my movies, but he still must be a very hardworking student.

Kamiki: With things like that whisper, you can't put in too much feeling, but you can't erase too much of it, either. I think you need both vocal technique and a good sense of the emotions of the role.

Shinkai: Kamiki really is a worthy voice actor. I suspect this may increase the number of animation job offers you get.

Kamiki: I really love the genre, so that would make me happy. Absolutely call me for your next film, Director Shinkai. I'll offer my voice to you anytime. (laughs)

The directing techniques of Hayao Miyazaki and Mamoru Hosoda: what's expected of actors in particular

Kamiki has performed voice-acting roles in the animated films *Spirited Away*, *Howl's Moving Castle*, and *Summer Wars*, which means he has worked under the direction of both Hayao Miyazaki and Mamoru Hosoda. Both are great talents and outstanding figures in the world of animation, along with Shinkai himself. Kamiki knows all three of them: Does he feel that they have anything in common, or that there are any major differences between them? And what about Shinkai, specifically?

Kamiki: They're all very different people, but I'd say they're all mellow; that may be the trait they all share. What I think sets Director Shinkai apart is his choices regarding the nuances in words. Words are a huge part of the draw to his films. I knew the way I tried to express those vague nuances would be important this time, too. Since I'm not a voice actor, though, it's pretty hard for me to maintain the same voice session after session. However, every time, Director Shinkai gave me good, meticulous, accurate instructions.

Shinkai: I'm not sure whether they were accurate or not... (laughs)

Kamiki: It seemed to me his instructions were based on a perfect grasp of what the "vagueness" in those vague nuances really was. I think those slight subtleties in the dialogue that give that sense of melancholy to his previous films were the result of his clear vision, of his desire for things to be a little more this way or that way. They seem ambiguous, but they're actually not. When you think about it that way, he really is an amazing person.

Shinkai: Well, no, there are times when I'm searching for the goal myself as I listen to the actors. As you say, though, at times I have a clear image of the tone and pauses I'm looking for. However, I do worry about what road I should follow to get there and what sort of take I need from the actors. That path isn't clear at all. (laughs) What do Miyazaki and Hosoda do about those things?

Kamiki: I was still a kid when I appeared in Director Miyazaki's films, so he would stand behind me and gently tell me things like "Do it a little more this way." For example, when I was Boh in *Spirited Away*, he'd say, "Try crying a little more, okay?" Director Hosoda started right off with "Yell." The film was already loud and exciting, so I threw everything I had into the performance, and I think Director Hosoda picked out the parts he felt were good.

Shinkai: So they basically let you do anything you like, within certain parameters.

Kamiki: That may have been because I'm not a voice actor, though. If I had been, they might have had a few more instructions about this and that for me, but as it was, they gave me free rein to perform in a variety of ways.

Shinkai: True, the things they expect from voice actors may be a bit different. It's likely that when they decide to have a screen actor play the role, they're at least partially anticipating something only you can bring to that role, something that wasn't in the original plan. This is true of the parts where the characters are physically moving, which I spoke about earlier, too. When I encounter something I didn't expect, I'm the one who gets all excited. Plus, I think the bits involving physical movement may have come out well because Kamiki usually uses his body to express things, so it might be *because* he's a screen actor. There are professional voice actors in *your name.* as well, and even if we do take after take with them, they don't shift around in the slightest. However, as Kamiki said, there are slight changes between each take for screen actors. That's fascinating. When the two types act alongside each other, the voice actors respond to what the screen actors do. The strengths of each group impact the other, and the result gradually turns into something brilliant and unexpected. Performances from a mixed cast of screen actors and voice actors are fascinating that way. This film really brought that home to me. It was incredibly fun.

A film made with the desire to encounter completely new scenery

Kamiki: With *your name.*, I was looking forward to seeing it finished, not just as a performer, but as a fan. That made me all the more concerned about how my own voice would sound when I watched it. When I watched the finished film at the test screening, though, I got emotionally invested in the movie and managed to listen to Taki's voice without really thinking about the fact that it was mine. We haven't shown it to an audience yet, so I'm worried about how the switched voice will go over. Director Shinkai gave it the okay, and he told me, "It's fine; it was good," but I can't relax; I'm still not quite convinced. (laughs)

Shinkai: It really is fine. (laughs) That said, I still can't view my own films objectively, either. Even if I think I've made something wonderful, as Kamiki says, we haven't shown it to audiences yet, so...

Kamiki: If you'd let me speak as a fan, then (laughs), I thought it was an amazing film. I thought this when I read the script, too, but it feels like you've taken a new step forward. As a movie, its tone is different from your earlier films, but the melancholy that settles over you as you watch is the same or even more intense than before. I don't think you're trying to create sad stories on purpose. But the end result is that there's always a scenario or a situation or a line that just makes your chest tighten. What you've cultivated hasn't changed. I can sense that growth and the effect that changing the tone has. I think some of it may surprise people who've been your fans for a while, just a little.

Shinkai: I didn't intentionally make any major departures from my earlier films in this one. However—and this is true of Kamiki's voice as well—I did want it to have the unique touch of various other people and become a more expansive work. I also wanted to see scenery that was a little different from the sights I'd had the opportunity to experience through my previous works, and I wanted the film to provide that opportunity. By "scenery," I mean the voices and demographics of the people who come to the theater, or the literal scenery when we go out on regional campaigns, for example. Up until now, each new movie I've made has shown me all different kinds, and I feel the films have brought so much to me in return. I've been doing this for ten years now, though, and I was just starting to feel that desire to meet the sorts of people I absolutely wouldn't have met before.

Kamiki: This is true of the visuals and the scenery they show as well, but I truly do think it's that type of movie. I get the sense something I've never seen before is unfolding in this animated film. Personally, I'm incredibly happy to have gotten to participate in a movie like this one.

Shinkai: I'm grateful to hear that. I was trying for a work that would take me someplace new, but I think it just might take its audience to new places as well. I specifically set out to make something like that, and it does feel as though I may have succeeded.

[Director]
Makoto Shinkai
Interview

The film *your name.* is bound to be met with simultaneous satisfaction and surprise. What feelings did Makoto Shinkai put into it? We heard all about the film's beginnings and the details of its creation straight from the director.

(Interview/Write-up: Mizuo Watanabe Photography: Yuji Hongo)

The motif and theme of this work are a perfect fit for his visuals

—*your name.* has been given the tagline "A tale of love and miracles." As director, did you pay particular attention to the fact that this was a love story?

Shinkai: I didn't set out to depict a romance. My motive was a simple one, I think: I wanted to create a story about a pair who were destined to meet but hadn't met yet. They're currently total strangers, but they're supposed to meet someday, and they keep connecting with each other in some way before that meeting occurs. To put it another way, it's a rather irregular "boy meets girl" story. Setting aside the question of whether it develops into love or not, the meeting between the boy and girl sets something in motion. It's a universal sort of story, but I wanted to show it through animation as mainstream entertainment. It would have been too simplistic as it was, though, so I scrounged up enough material to allow it to stand as a movie, then pieced it all together.

—As a result, dreams became the motif, and it's a *Torikaebaya* story, where the girl and boy switch places.

Shinkai: I'd had in mind all along the idea of using dreams as the motif, and a *waka* poem by Ono no Komachi in the *Kokin Wakashu* caught my attention: "Had I known it was a dream, I would not have awakened." From there, I gave my story a bit more of a twist and went from meeting in dreams to making that contact *as* the other person, while the other person is no longer him- or herself. Once I had the scenario of switching places in dreams, it struck me as a perfect match for the theme in my visuals. I thought that seeing Tokyo for the first time

"The tale of this encounter feels like a wish for another's happiness."

through the eyes of a girl who lived in the country and experiencing a boy's reaction to the opposite would let us use the scenic shots we'd taken so much care with in previous works to maximum effect. It seemed to me that if I managed to blend those visuals into a story mechanism and show them in that light, it might turn into a movie with a good shot at being successful.

—The fact that they're switching with each other highlights the fact that they're "meeting," but they haven't yet met. They're incredibly close, yet incredibly far. Parenthetically, in your mind, is there an in-story reason that the two who switched were Taki and Mitsuha?

Shinkai: I didn't give a reason for that, did I? Why was Taki the one Mitsuha reached out to, and why was Mitsuha the one Taki's dreams connected with? That issue came up in our script meetings as well, but ultimately, I thought it wasn't important. Even in reality, you can't logically explain why you meet someone and why you fall in love. Before you know it, you've met someone, and you're in love. The same is true for the switching in the dreams; it just is what it is. At best, it's a tool, a hook for the encounter. What I wanted to show was a small exchange between hearts that expands outward to a vast, cosmic scale, and so, to that end, I thought of the "braided cord" and "comet" devices at the same time.

—Where did you get the idea for the braided cord motif?

Shinkai: The cords are from the sci-fi notion that minds are linked and tangled together on the quantum level. Meanwhile, I'd been considering the idea of a town vanishing all along. Then, as I was wondering whether I could use cords to show the uniqueness of a particular region, I arrived at the idea of traditional braided cords. The pattern on Mitsuha's braided cord isn't shown clearly in the movie, but if you unwind it and lay it out, the design shows a sunset with a lake at its center. The idea behind it is that it's the town of Itomori and half-light, turned into a pattern.

—The comet is also a striking motif, isn't it?

Shinkai: I initially thought of the comet because it would make an attractive anime visual. Natural and astronomical phenomena create a real visual impact, and they look beautiful. In *The Garden of Words*, for example, I used rain. I'd also had in mind the concept of a tradition that had been handed down since antiquity, and I thought, "Comets are cyclical cosmic phenomena." The fact that Mitsuha is a shrine maiden tied into that as well, and the trigger for the idea may have been the numerous natural disasters we've had in recent years. Natural disasters are cyclical and region-specific; for example, in an area where there was a tsunami long ago, I've heard they found a stone marker with a warning about the disaster. In most cases, though, as time passes, these things are forgotten. I wanted to incorporate those elements into the comet and its legend, the shrine maidens' dance and the braided cords, and the history of Itomori itself.

—Tell us about the origin of the title *your name.*

Shinkai: I'd originally used part of the Ono no Komachi *waka* poem "Had I Known It Was a Dream" as the title. It didn't necessarily reflect the film's content, but I thought it had a nice ring to it. After that, since they were half of each other, I had *You're Half of This World*—which was also the tagline for *Cross Road*—and *A Half-Light Love*, which expressed the film's content simply, as temporary titles. However, they weren't that catchy, and we discussed what to do up until the last minute, and somewhere in there (Producer Koichiro) Itou said, "Wouldn't *your name.* work?" I'd thought of that myself, but there's already a famous film by that name, so I hadn't been able to make a final call on it. Looking back, though, I think that title was inevitably the right one.

A film constructed by a galaxy of talent

—The staffing for this film was an encounter as miraculous as the movie's, wasn't it?

Shinkai: I really do think that exceptional people came together with miraculous timing. It had been ten years since RADWIMPS made their major debut, and they were just thinking about branching out and trying something a little different. On the animation side of things, (Masashi) Ando wasn't currently working on a theatrical project, and although (Masayoshi) Tanaka was busy, he participated as much as he could. This film has the sort of lineup that may never be seen again. That was one more reason it felt so intensely worthwhile.

—Speaking of RADWIMPS, you were the one who initially brought up their name, weren't you?

Shinkai: I just answered the question "What artists do you like?" I never dreamed I might get to work with them. (laughs) But Genki (Kawamura; planning and production) knew Yojiro (Noda), and while they were talking it over, it was decided that they'd do the film's soundtrack as well. I knew that would be incredible, but I couldn't really visualize how it would work, production process included. Still, when I heard the first song they wrote, which was based on the image they had of the script, those worries all went out the window. I'd gotten something absolutely fantastic, and I switched over completely to the question of "How do I effectively put this to work in the context of the visuals?"

—What sort of adjustments did you make, specifically?

Director Shinkai in meetings at the studio.

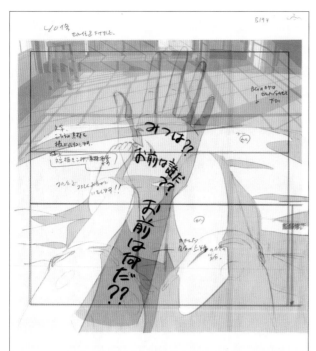

Shinkai: "Zenzenzense" was the song that they initially created based on the script image, and there are lyrics that are only in the movie version. "Will we be able to get past / the future up ahead, the countless troubles? / Remember what I said? / If we're together, I just know we can smile and beat them back." Those lyrics. They're really universal, aren't they? While they describe Taki's and Mitsuha's feelings in the movie, they also speak to adolescence itself, you know? I actually cut lines from the movie so that people would be able to hear those lyrics. Every time I make a film, I put together a proper blueprint. This time, though, I was blessed with a galaxy of talent that I couldn't have imagined at the time of the initial project write-up, so the film ended up being constructed by everyone, and it completely surpassed my blueprint. I was thrilled to find I'd miscalculated.

—Ryunosuke Kamiki's and Mone Kamishiraishi's voices were also a big part of that, weren't they?

Shinkai: I'd always liked Kamiki as an actor, but I was surprised at how clever he was with his voice. It was brilliant. I may annoy Kamishiraishi by saying this, but to me, Mitsuha is Kamishiraishi, period. Plus, her skills were outstanding as well. She grasped the little details for her basic performance perfectly from the video storyboard guide, then added so much to that. It startled me.

—And then Mr. Tanaka and Mr. Ando, whom you mentioned earlier. What was it like to work with those two?

Shinkai: Tanaka's characters are cute and cool. He drew protagonists that everyone can genuinely like and sympathize with. Then Ando went to work on them, and all I can say is that I'd expect no less from Ando. He showed through his work, once again, that you can't head into a movie without proportionate focus and dedication to back it up. I'm really and truly indebted to both of them.

The ending's encouragement to "find happiness"

—Do you feel you attempted anything new as far as the theme of this film?

Shinkai: In terms of theme, I think it's really an extension of my previous films. There's that line of Taki's, "I'm always looking for something, for someone," and I think there are a lot of people who will associate that with 5 *Centimeters Per Second*. In addition, "communication when meeting is impossible" is something I've done over and over ever since my debut work, *Voices of a Distant Star*. That said, I do feel that the way I tell it has changed quite a bit.

—I would imagine that there are many people who will compare this film with *The Place Promised in Our Early Days*, but together with *5 Centimeters*, I think the deep emotion of that ending is something entirely different.

Shinkai: We held the world premiere in Los Angeles, and when we screened it there, I got the feeling everyone had been waiting eagerly for an ending like this. The people who came to Los Angeles to see it had been fans of my work for a decade, and from what I hear, the question of whether Taki and Mitsuha would meet at the end was a big concern for them. There's a scene set a few years later where the two of them pass each other on a pedestrian bridge, and when they did, everybody groaned in despair. (laughs) It was as if they felt that, yes, that was where it was going to end. After that scene, there were incredible spikes and dips in their emotions; the music played, the sights of Tokyo appeared, and then Taki and Mitsuha started being shown by turns, and at that point, the audience started to buzz, and when they passed each other on the trains, a huge cheer went up. After that, everyone just kept on shouting. (laughs)

—And that was what you were aiming for.

Shinkai: I'd tried to make *The Garden of Words* a film that would have audiences leaving the theater happy, too. However, I heard that it left some people feeling gloomy. This time, Ms. Okudera tells Taki, "You'll find happiness someday, too"; while the words may seem a bit cryptic, they're my wish for the audience as well.

—So it's a message from Ms. Okudera to Taki, and also a message from the director to the audience.

Shinkai: I wanted to make a film that held a wish for another's happiness. However, if you look at it a certain way, the ending of *your name.* is just the beginning, and it's not as if everything after that point is guaranteed. It's always pregnant with the potential for some sort of ending, a feeling that is shared with all my previous films. That's just how reality is; there's no other way to put it. In "Nandemonaiya," the RADWIMPS song that plays as an epilogue, they sing "I want to stick together, even if it's just for a little longer," and I thought that feeling was exquisite.

Near the end, in the scene where Taki's job hunting, I have him say, "The way I see it, there's no telling when even Tokyo could disappear," and I think people feel more strongly every day that their familiar routine might vanish eventually. However, they want things to stay the way they are, even if it's just for a little longer. They want to be with the people they love. I think happiness is the sort of thing you begin to see only when you're experiencing these pressing emotions. I'd wanted my previous films to be like that as well, but I feel as though this time, I've finally managed to create something I can be satisfied with.

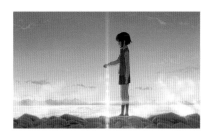

MAKOTO SHINKAI

Born in 1973 in Nagano Prefecture. Debuted in 2002 with the short film *Voices of a Distant Star*, which he produced on his own. He subsequently released *The Place Promised in Our Early Days*, *5 Centimeters Per Second*, and *Children Who Chase Lost Voices*. His greatest hit came with *The Garden of Words*, released in 2013. The film won the grand prize in the Feature Film category at the Stuttgart International Festival of Animated Film in Germany. As an up-and-coming film director, he has been the recipient of high acclaim and support both domestically and overseas.

TOKYO LOCATION MAP

In general, the Tokyo segments of *your name.* take place in the area between Shinjuku Station and Yotsuya Station. On these pages, we'll take a look at the important sites that appear in the film. (Text: Motoki Kurata)

▸ SHINJUKU
▸ YOYOGI ▸ SUGA SHRINE
SENDAGAYA▸ ▸ YOTSUYA
▸ GAIEN
▸ ROPPONGI

SOBU LINE

▸ TOKYO

YAMANOTE LINE

Comment from Director Shinkai

In the film, country girl Mitsuha dreams of the sights of Tokyo, while Tokyo native Taki is captivated by the landscapes of Itomori. To bring it to life, I went around scouting for locations that could be used to show Tokyo's unique beauty. I used a lot of reflected light and coloring tricks to keep the dense areas of skyscrapers from becoming inorganic and cold.

SHINJUKU
● 新宿

The South Exit of Shinjuku Station is where Mitsuha, as Taki, is blown away by the view and cries, "It's Tokyo!!" The pedestrian bridge in front of the Sompo Japan Nipponkoa Head Office Building, a Shinjuku landmark, is where Mitsuha and Taki pass by each other when they're a little older. The fact that Teshigawara and Sayaka were nearby right before it happened makes you think they and Mitsuha may still meet up in Tokyo…

The café where Teshigawara, Sayaka, and Taki all end up together, completely by accident, is just beside that pedestrian bridge as well (lower right). The electronic billboard at the East Exit also shows up several times during the film (lower left).

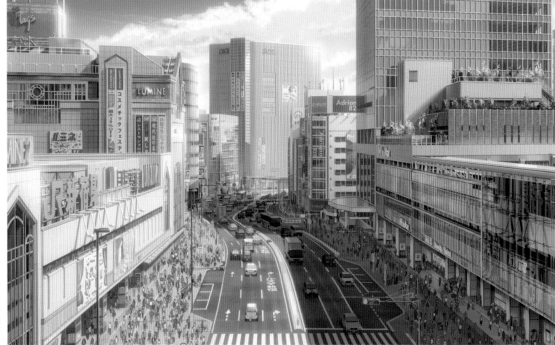

This scenery at the South Exit appeared almost immediately after its 2016 redesign.

GAIEN ●外苑

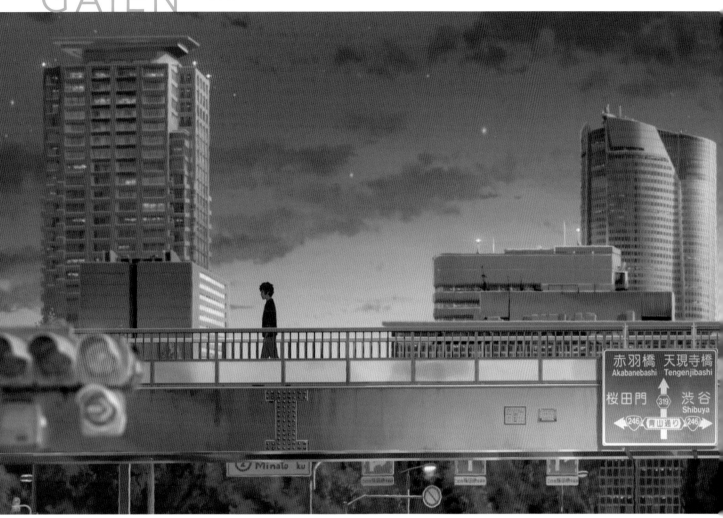

This pedestrian bridge, which shows up in key scenes again and again—during the opening credits, on the way home from Taki's part-time job, and during the date—could easily be called a symbol of the film. It's just outside Shinanomachi Station, and beyond the bridge is the scenery of the Gaien area. The Roppongi Hills building, where Taki and Ms. Okudera went on their date, is also visible at the right of the image.

The pedestrian bridge is striking for its view of a seemingly bottomless sky. A single location-scouting photo clearly shows how meticulously it was recreated.

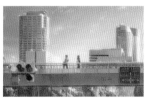

Even though the composition is the same, changes in the time of day and in characters' emotional states give it a completely different atmosphere.

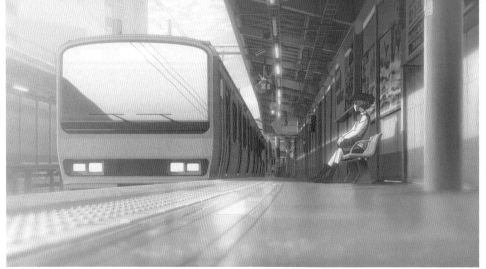

YOYOGI STATION
● 代々木駅

Mitsuha came to see Taki and walked around searching for him, but she couldn't get through to his phone. She was sitting on a station platform, at a loss for what to do, when she spotted him on an arriving train. Yoyogi Station, with its rather bleak atmosphere, was used to good effect in this scene, which shows Mitsuha's melancholy and loneliness against a sinking evening sun.

A platform on the Sobu Line for trains running to Chiba from Shinjuku. The NTT DoCoMo Yoyogi Building, a familiar sight in Shinkai films, is very near the station.

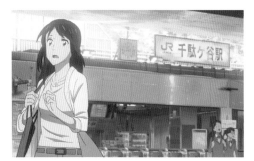

SENDAGAYA STATION
● 千駄ヶ谷駅

The moment Taki and Mitsuha, now adults, passed each other on trains going in opposite directions, they disembarked and began looking for each another, like a pair of magnets. Sendagaya Station makes an appearance as the station where Mitsuha hastily leaves her train.

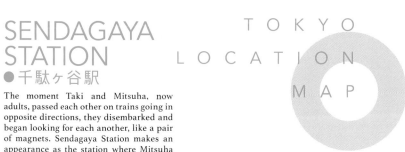

TOKYO LOCATION MAP

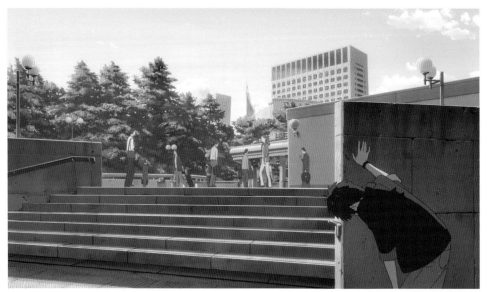

YOTSUYA STATION COMPLEX
● 四ツ谷駅前

As the closest station to Taki's place, Yotsuya Station shows up in a variety of situations, such as the meeting spot for his date with Ms. Okudera or the place where Mitsuha wanders aimlessly (as Taki), knowing nothing about how to get around Tokyo. The scene where Mitsuha meets Taki for the first time, telling him her name as she unties the braided cord in her hair and gives it to him, is set on a platform here at Yotsuya Station.

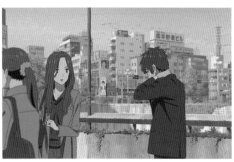

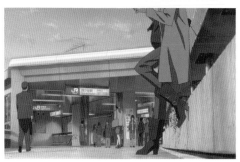

The plaza in front of the station shown in the movie is at the Akasaka Exit. Various scenes show the area around the station from different angles.

When Taki and Ms. Okudera ended up on a date, courtesy of Mitsuha, they headed to Roppongi. First, they visited Tokyo City View, the observation deck inside Roppongi Hills, before heading to the National Art Center.

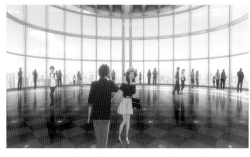

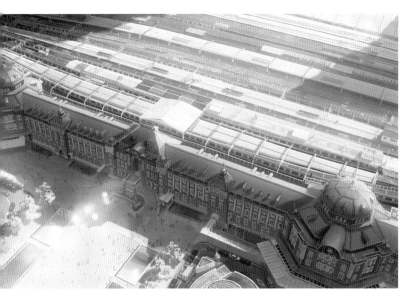

TOKYO STATION
● 東京駅

The enormous terminal station, which serves as Tokyo's front door, was declared an important national cultural asset in 2003. It appears in the scene where Taki sets off for Itomori, relying on his memories.

The pair had lunch at the Salon de Thé ROND, inside the National Art Center. It's a popular café, with a seating area on top of an inverted cone.

SUGA SHRINE ENTRANCE
● 須賀神社入り口

Five years after the comet fell, the pair had lost their memories of the past. But when the trains they were riding passed each other, they found each other again. The entrance of Suga Shrine in Yotsuya was used as the location for this striking last scene. Its location, surrounded by Shinjuku, Yoyogi, Sendagaya, and other major stations that appear in the film, heightens the emotion of the scene.

Suga Shrine has enshrined the local Shinto deity of Yotsuya since the early days of the Edo period. It's located in the middle of a residential area, and the shrine precincts begin at the top of these stairs.

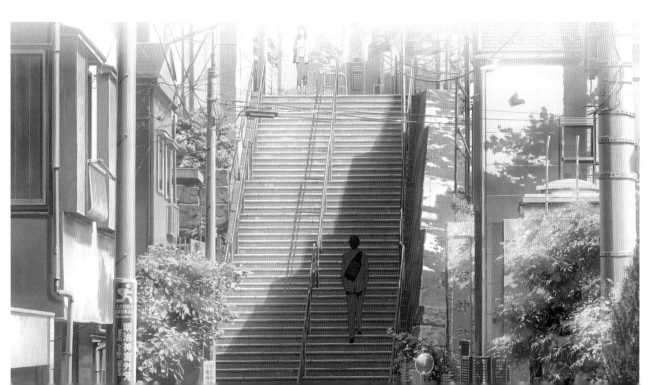

[Animation Director]
Masashi Ando
Interview

Masashi Ando, an expert known for his work on Studio Ghibli films, served as the art director for *your name.* The film was both his first job with Director Shinkai and his first time working with Masayoshi Tanaka. What did the experience mean to him?
(Interview/Write-up: Mizuo Watanabe Photography: Mikio Shuto)

Why he participated in the film: unexpectedness and possibility

—What was the biggest factor in your decision to participate in *your name.*?

Ando: In the first place, I never thought an offer for one of Shinkai's films would come my way. Looking back, I think that unexpected request was a major factor. There was a lot I had to consider, but they sent over the scenario as informational material, and I found it incredibly interesting. Plus, at that point in time, it had been decided that (Masayoshi) Tanaka would be doing the character design, and they wanted to know if I would take the position of art director with that in mind. Based on the films we'd worked on up till then, having me do the art direction using characters Tanaka had designed seemed like a pretty unusual idea. That alone was enough to catch my attention, in a good way, and I decided I'd give the offer some consideration.

—You've worked on Ghibli films, Tanaka works on modern animation, and Shinkai has forged his own unique path. That really is a singular combination, isn't it?

Ando: I think the characters Tanaka draws are very vibrant, in animation terms. I tend to work on projects that are rather plain and foolishly straightforward (laughs), so I wondered what would happen if I worked with his characters. That curiosity is a big part of why I joined the project. I was also working on a short film for Takeshi Honda at the time, and Honda is a man who can really do both. He's able to make the characters give a solid performace while at the same time bringing an anime-style vibrancy to them. I was incredibly impressed watching him work; I thought, "I can't do anything like that. That's amazing," and right about then, I got this offer. I thought if I hitched a ride on Tanaka's characters, they might pull me along and expand my own potential, so I took the job with the intention of tackling a new challenge as well.

—Do you feel that it did expand your potential?

Ando: I don't think it's expanded all that much. It's partly because I was hard-pressed to keep up with the work, I think, but it's not the sort of thing you can do that easily anyway. (laughs) Since they are Tanaka's characters, I think maybe I should have used them more enthusiastically during comical scenes and situations as well. Still, it was difficult to strike the right balance, and I just couldn't bring myself to leap out of my comfort zone where I feel I have control. On the other hand, this isn't a story that can get by on comedy alone. As we got into the latter half, it naturally grew more serious and heavy, motions included, and we had to use expressions that closely resembled reality. If there was a time when I could have played around in various ways, it was the frenetic part in the first half. It felt solid, but it also feels like it wasn't enough... Well, I think I managed to fulfill the minimum requirements. (laughs)

Rendering characters' sexiness

—How does the film feel to you, now that it's taken shape?

Ando: I think it feels incredible. The feeling I got when I first read the scenario, that this was something good, is still there in the completed film, unchanged. What I was first drawn to was the structure of the story. The boy and girl are experiencing that frustration peculiar to adolescence, which comes through very strongly, and even while they're at the mercy of something they can't control, the wheel of fate or what have you, they manage to find the light. Even when I see it all connected, the flow of the film is just as we designed it to be. It's smooth and pleasant. I think it's something that young people will really be able to enjoy watching.

—You think it's a film that represents the younger generation, then?

Ando: As an older person, there are parts that concern me a bit. (laughs) At the end, when we showed some of what the characters are doing now, I would have liked to include Grandma (Hitoha), even if it was just a shot of her back. By the end, Mitsuha and the others have moved to the city, but Grandma spent her whole life protecting that shrine, and I really wonder what she's doing now that it's gone. Maybe I only think that because of my own personal emotional investment, though; when I first read the scenario, it wasn't a question that occurred to me. It's written so that you won't worry about things like that. However, when you give so much thorough consideration to the expressions a person will make and what they're probably thinking, when you're drawing Grandma and making her move, you start to wonder about what ultimately happens to her. (Etsuko) Ichihara's voice acting is good, isn't it? She's an actress I personally like as well, so I did get genuinely emotionally invested.

—I see. What sort of sequence would you visualize?

Ando: Possibly that Grandma has moved somewhere other than Tokyo, by herself, and is working with Mitsuha's father on some initiative to restore Itomori. No one asked me, though; I think about these things on my own. (laughs) Although in reality, it's hard to know what that would look like once it's been taken out of context. I think she's working to make sure that what they protected for so long is handed down in some form. That's how I'd like it to be.

—You mentioned making characters move. Were there any points you kept in mind for the protagonists, Taki and Mitsuha?

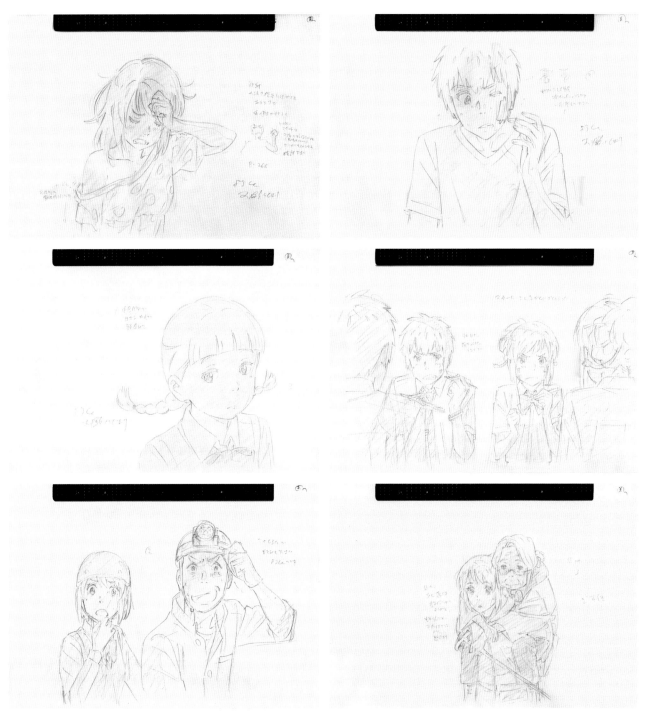

Corrections by Masashi Ando

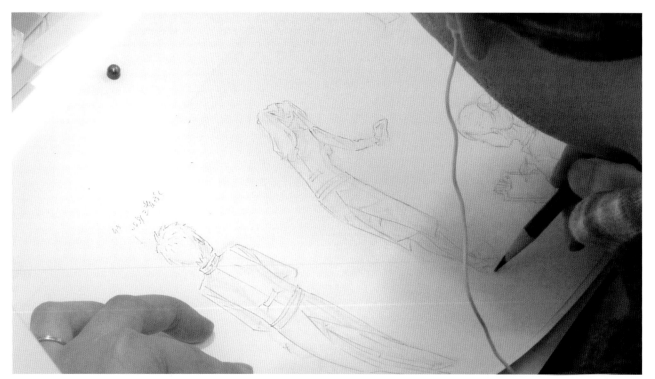

Ando at work in the studio. (Ando's note reads: "Taki, slim, Mitsuha-ish")

Ando: For Taki and Mitsuha, it was hard to figure out how to show the switch while still maintaining their designs to a certain extent. With Mitsuha, we added a change that was easy to see: When her hair is braided and tied up, she's Mitsuha, and when it's in a ponytail, she's Taki. In the last half, though, she cuts her hair, so then they tended to get mixed up. At that point, we had the animators buckle down and use her expressions to show the transformation. When she's Mitsuha, her face shows unease more readily, and when she's Taki, his sense of purpose shows through more prominently. We worked carefully, figuring out how much of those differences we needed to put in to make the distinction. I'm still a bit worried about how well we actually did.

—Which other characters did you put extra effort into?

Ando: I was careful with Ms. Okudera. How should you draw a moderately sexy adult woman? In animation, how you want to approach the concept of "sexiness" is an issue as well. This may not be quite the right way to put it, but I really wanted to differentiate her from the types of characters that "anime fans" support, the ones that make the second dimension so appealing to them. Personally, it seems to me that all characters should be sexy, not just women with that pheromone-type attractiveness like Ms. Okudera. When I say "sexy," though, I don't mean eroticism; it's something more akin to their vitality.

—In other words, it's like the nuances deep inside characters.

Ando: There's a phrase that gets thrown around a lot—"the other side of the character"—and even I'm pretty tired of hearing it (laughs), but the pictures you draw really are no more than the artist's representation, and you do visualize a real live person beyond them. Real live people are what give you clues when you're trying to depict sexiness or vitality. If you can glimpse the vitality of a real person in the drawing, the character will have that same spark. It's making them convincing and giving them a sense of presence as a living being. That's true for Ms. Okudera as well; I hope we managed to make her seem sexy as a woman and give her human vitality.

—In terms of technique, how does one go about reflecting that?

Ando: It means not drawing pictures using theoretical lines. When you draw, you do your best not to be symbolic, not to fall back on the idea of "This is what a person is." A while back, Yoshifumi Kondou, whom I respect, talked about observing human skeletal structure. When you draw a person, people tend to have the idea that there's a torso, and the neck is on that, and then the head sits on top of the neck, but if you think of it in terms of skeletal structure, the torso and the neck are one continuous sequence. The spine is shaped like an S, and it bends forward to support the neck, so the back of the neck isn't perfectly straight; it's tilted. He said something like, if you think about the fact that the body's lines are created

that way, you can't help but show it. If you incorporate those little considerations into your drawing, you make it convincing, generate a sense of life, and I think that links to sexiness.

—To put it another way, you're saying that their realism as characters is tied to sexiness.

Ando: Because the neck connects at an angle, when the person turns around, there's a tilt to it that creates a sort of depth for that person. It's simpler to draw people as patterns, but if you do it that way, it becomes dangerously easy to fall into the realm of theory, and personally, I'm rather afraid of that. I'm speaking in terms of my ideal manner of drawing, but I've come this far aiming for that ideal.

—Ms. Okudera specifically isn't a coquettish type. She's mischievous and genuine, and that's linked to her character's sexiness; I'd imagine that makes things difficult.

Ando: I thought it would be best if we didn't draw her in unnaturally twisty poses, for example. I considered how we could take that approach, yet still leave people with the sense that she was sexy, facial expressions included. When Ms. Okudera first makes her entrance, I think the audience is syncing with Taki's subjective perspective, and as they watch, they can clearly tell a gorgeous and sexy woman has arrived. For that reason, we had to emphasize her sexy, feminine side at that point and make it especially obvious. After that, though, as the story progresses, Taki's feelings change, and so does the way he sees Ms. Okudera. At those times, we were able to show her as pretty absentminded or frank and laid-back, while also keeping in mind her cuteness is more than just her sense of style or eye-catching looks. In this way, the audience got to experience an unexpected side of her, and it seemed doing so would expand Ms. Okudera as a character. Especially when she's traveling with Taki and Tsukasa, I thought it might be all right to make her seem a bit innocent and childlike.

A film in which one senses a drive for major-league craftsmanship

—Once again, what was your impression of Shinkai's work?

Ando: I'd watched and enjoyed his previous films, beginning with *Voices of a Distant Star*, but with *your name.*, I feel as though he's made it onto the list of major works at last. I think it's a film that the general public will have an easy time accepting. It seems to me that, after all is said and done, his previous films were created and viewed as independent films. However, I do think that that's part of what made them good, and that was an advantage of Shinkai's as well.

—There are definitely unique advantages to films from smaller studios, aren't there?

Ando: I think the benefit of making independent films is what their lack of polish can bring to the table. It's a quality that's defined Shinkai's successes up to this point. To a certain extent, they're performances with limited venues, which is why what the film wants to accomplish becomes more important precisely because it lies outside the mainstream. I think the important point about indies, and what they excel in, is not how well they've managed to do whatever it is they set out to do, but whether they managed to capture what they wanted to express. In his previous films, Shinkai demonstrated that to his heart's content. Coming from that, with his current film, *your name.*, it feels as though Shinkai has managed to execute a kind of craftsmanship geared toward a major label within the range he can reach, without overstretching himself. I think it came out extraordinarily well balanced.

—You really could say that the film has taken him into new territory, in various ways.

Ando: In the big leagues, how well you've managed to achieve a variety of things—including what you want to show and the technical aspects—becomes a necessary question to consider. However, I think that Shinkai has finally reached a place where simply including what he wants to do won't be enough and where he can't afford to see lack of polish as a good thing. It does mean creating something that will stick around, but naturally, the things he wanted to express through the work and its technical aspects will fade over time. For that very reason, what's important is whether you did the very best you could do, and only the films made with the very highest level of effort stand the test of time. I think *your name.* is a film in which you can sense that drive.

| MASASHI ANDO |

Born in 1969 in Hiroshima Prefecture. In 1990, he joined Studio Ghibli as a second-term research student. He worked as the art director for director Hayao Miyazaki's films *Princess Mononoke* (1997) and *Spirited Away* (2001). After going freelance in 2003, he continued to demonstrate his talents on Studio Ghibli films and director Satoshi Kon's films. For *When Marnie Was There* (2014), he acted as art director for his first Studio Ghibli film in fourteen years, and he also supervised the script. The list of films on which he has been in charge of character design and art direction includes *Paprika* (2006) and *A Letter to Momo* (2012).

[Character Design]
Masayoshi Tanaka
Interview

Working under the talented writer Makoto Shinkai, Masayoshi Tanaka designed fascinating characters brimming with emotion. We asked him about these vibrant people living in the heart of the city and the town in the mountains and where he took special care with them.
(Interview/Write-up: Hitomi Wada Photography: Mikio Shuto)

Finding the balance
between comical and serious

—What did you think when you saw the finished movie?

Tanaka: Due to my schedule, I was only involved as the character designer this time. Masashi Ando handled the art direction. To me, Mr. Ando is a sort of godlike figure, and I felt I owed so much to him; I was incredibly fortunate to receive the offer. However, I'm more of an animator than a designer, so to be honest, I was both expectant and anxious about not being able to act as art director. When I got a look at it, though, the good far outweighed all of that. As a designer, I'd say I really couldn't have asked for more, and the screening was a rich time that left me fully content. In addition, as a fan of Director Shinkai, I could keenly sense that he's a really stubborn person. He commits himself no matter what changes, whether it's the budget or a system, and he draws what he wants to draw with everything he has. It reminded me once again that he really is a writer.

—How did you first meet Director Shinkai?

Tanaka: The first film of his I saw was *Voices of a Distant Star.* At the time, I was working with Director Akitaro Daichi, and it was a hot topic at the studio; everyone was talking about how amazing it was. After that, whenever one of his films was released, it was on my radar, and a few years ago, I actually got to meet him. It started with a cross talk interview between Shinkai and Tatsuyuki Nagai when *Anohana: The Flower We Saw That Day: The Movie* and *The Garden of Words* were released. After that, Nagai bragged to me, "Hey, I met Shinkai" (laughs), and so a mutual acquaintance of Shinkai's and his—Miyu Irino, actually, who starred in both their films—set up a dinner party for us. There were just four of us there: Shinkai and Nagai and Irino and me. The conversation was lively, and as a matter of fact, that was where we made the spur-of-the-moment decision that I'd participate in the "Z-Kai: Cross Road" commercial. Shinkai said, "Let's work together, absolutely," and I told him, "I'm free right now, so I'll do it!"

—So the team came together in a place that had nothing to do with politics.

Tanaka: Both of us were getting very excited about it, but it felt like, "Can we actually do this?" By the way, one other thing that got decided at the time was that we'd appear on Irino's radio show. We all said we'd go, we would definitely be there for sure! But maybe the others couldn't make it work with their schedules, because I was the only one who actually went. (laughs)

—How did you go about making the character designs this time?

Tanaka: I got involved at the stage where the scenario was still being developed, soaking up information about what Shinkai was aiming for. What made a particular impression on me was his statement that, all else aside, he wanted to do comical scenes. In the end, I think that became the biggest distinguishing feature of this film, and I thought maybe he'd called me in because he had faith in my instincts for balancing the comical and the serious. For that reason, I paid quite a bit of attention to that when I was drawing up the design proposals. Ando was astonishingly mindful of that point as well, and I could tell he was carefully considering the nuances, such as the way I draw more distorted expressions. I felt so honored.

—Live-action scriptwriters sometimes designate actors for roles and write for them. Did it feel as though there were any scenes written directly for the characters or expressions you drew?

Tanaka: Director Shinkai may say that wasn't the case, but I did get that impression. During "Cross Road," he particularly liked a comical bit that I'd ad-libbed and put in. To me, it was something I did naturally as part of my job, but Shinkai and the people from CoMix Wave Films gave it a much bigger reaction than I'd expected. I really felt that at that studio, I might have a role to play in that area.

The shapes of the characters that populate the film's world

—How did you come up with the design for Taki, one of the protagonists?

Tanaka: I think most of Director Shinkai's male protagonists tend to be distinctly delicate types, but I thought he might want to take things a step further this time. He wanted my drawings to incorporate strength or roughness or a similar idea, but he also wanted me to keep a sort of gender-neutral feel in mind so that things wouldn't get creepy when Mitsuha's soul was in his body. Taki was created to fit that image, but I think Kamiki's acting ultimately helped me out in a very big way to make that happen. I went to see the recording session as well, just for a day, and while I was there, I was startled by how good Kamiki's and Kamishiraishi's instincts were. Actors who specialize in live-action work tend to bring it a little too down-to-earth and realistic, but with them, while they had a very grounded presence, there was a bit of "anime-style" panache in there as well. It was a really great balance.

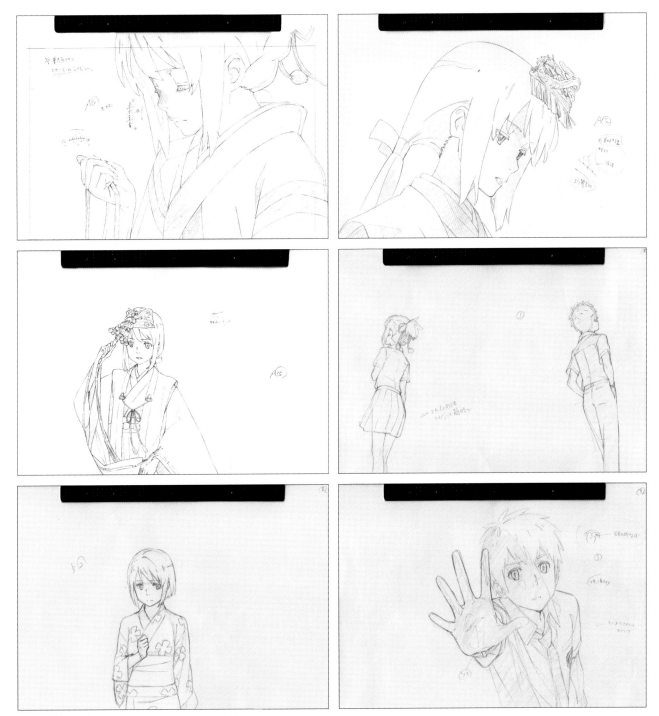

Masayoshi Tanaka's corrections to the opening credits sequence.

—What about the other protagonist, Mitsuha?

Tanaka: The braided cord was already an important factor in the story, so I started by thinking of ways she could casually wear one and went from there. I decided she'd wear it in her hair, so then I thought about her hairstyle. I wanted something that caught the eye but wouldn't stand out too much. I settled on a modified ponytail. I came up with the concept of braiding her hair, then tying it up all together, but Ando's the one who came up with the specific style.

—When she switches with Taki, that style changes, doesn't it?

Tanaka: Taki probably wouldn't be able to do Mitsuha's hair the way she did, so we imagined that tying it back was the best he'd be able to manage, and that was where the Mitsuha with the messy ponytail came from. I like it; it lets you tell at a glance that Mitsuha and Taki are switched. Girls' hair is nice; you can play with it and create variations. Besides, when there's something that swings, it lets you make the shot livelier.

—In Mitsuha's case, in the second half, she cuts her hair as well.

Tanaka: That hairstyle just keeps changing, doesn't it? I remember discussing whether we should just crop it or make it a short, boyish bob when she cut her hair. In terms of the studio, bobs are pretty difficult. The individual differences between animators are vividly apparent in the way they add movement to the hair, so it makes it hard to keep the art consistent. Still, what Shinkai had in mind was indeed a roughly chopped-off bob, so it ended up being what it is now.

—Tell us about the other characters, too.

Tanaka: I think my personal art quirks show up most strongly in Ms. Okudera's design. She's positioned to be what you might call everyone's "idol," so I took quite a lot of care when I designed her, clothes included. I was worried whether those subtleties would come through properly in the movie, but really, they drew her brilliantly. When I saw the finished visuals, my energy just soared through the roof. I thought, "Ms. Okudera's way cute!" When I went to watch the recording, I accidentally said that out loud, and apparently the people around me thought I was complimenting her actress, Masami Nagasawa. (laughs) I mean, of course Ms. Nagasawa is cute, but it was the Ms. Okudera on the screen who affected me so much.

—Her feminine, age-appropriate makeup and wardrobe were striking.

Tanaka: Putting lipstick on an animated character is a pretty risky thing to do all on its own. It's very difficult to apply cosmetics in ways that match those deformed, anime-esque lines. You have to make the lips look properly three-dimensional, and one wrong move will immediately make them too flashy. Still, that was also done even more beautifully than I'd anticipated, and she did seem like everyone's idol. I was happy. Also, one of Ms. Okudera's key features is the bangs that fall over her eyes. That angle and those lines are important. There's no real logic behind it, though. It's just design sense, so it's hard to define, and there aren't many animators who will grasp things on that level. Still, as you'd expect from Ando, that seems to have been a piece of cake for him, and he worked it in perfectly. Her little gestures and the selection of her cigarettes and other accessories were also very well done.

—Taki and Mitsuha's friends are also fun and charming.

Tanaka: The designs for Tsukasa and Takagi are in the same vein as my previous characters. Since Tsukasa was meant to represent the city in a way, I made him seem intellectual and a bit cynical. Takagi is based on the image of Poppo (a character from *Anohana*). For their older versions, I didn't make any big changes to their designs; I just shifted them over pretty much as they were. On the Itomori side of things, the one I paid the most attention to was Teshigawara. It sounds as though Shinkai had a solid concept for him right from the beginning, but I took the risk of attempting to crush it. I drew a delinquent type with a bit of a ducktail-style hairdo, and it was shot down beautifully. (laughs) I like characters with burr cuts, too, so I did have fun drawing him. Sayaka was tasked with being representative of country girls. I put in all the things I think of when I think "country girl," including pigtails. ...You know, I just realized this, but now that I'm thinking about it, the Itomori girls—Mitsuha, her little sister, Yotsuha, and Sayaka— they aren't styled exactly the same, but they all wear their hair tied in two pigtails, don't they? Even Mitsuha divides her hair into two braids before she ties it up... Wow, my creative vision was pretty bland there, huh! I see. That's a kind of a shock! (laughs)

—Are there any key challenges when it comes to drawing characters of varying

Tanaka in a preliminary meeting with Director Shinkai.

ages?

Tanaka: There were three dads in this movie: Mitsuha's, Taki's, and Teshigawara's. You don't get many opportunities to draw and differentiate so many middle-aged guys, so that was fun. I also kept the genetic connections between each father-child pair in mind. Since Mitsuha's dad is the mayor, I thought it might be good to make him look affable, but Shinkai told me "Make him more like a final boss!" so I kept him strict and rather dapper.

A studio like no other: image creation found nowhere else

—How did your involvement with this film inspire you?

Tanaka: Shinkai was the first director I'd teamed up with who works on everything from the script to the direction and has worthy abilities as a writer, so it was energizing for me to get to connect with the clear vision inside him. When you meet him under ordinary circumstances, he seems rather vague and mild, but he's tremendously obstinate when he feels something isn't negotiable. Not only that, but in Shinkai's case, he looks deep into the filming and other composite areas. It struck me that that's precisely how those extraordinary shots are created. Also, as an animator, I learned a whole lot from seeing how Ando worked. Ando really faces his drawings seriously, and he steps into each individual shot with uncommon depth. I'm already forty, but he reminded me of how I felt when I was just starting out, and that I'd aspired to be like that.

—Finally, tell us what the appeal of Director Shinkai's films is to you.

Tanaka: This may sound paradoxical coming from me, but I think Director Shinkai's appeal is that he's able to create solid films even without relying on the characters or the art. Shinkai started out making films all by himself, and I think that alone is enough to sum it up, but I'm sure what's at his core hasn't changed from what it was back then. That's a strength, and that's why I hope I get to work with him again.

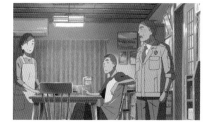

| MASAYOSHI TANAKA |

Born in 1976 in Hiroshima Prefecture. Debuted as an animator in 1998. His first character designs were for the 2006 TV anime *Reborn!* In 2008, he teamed up with Tatsuyuki Nagai (director) and Mari Okada (series composition) for the TV anime *Toradora!*, for which he was the character designer and general art director. Working with the same team, he helped release other popular works into the world, such as the TV anime *Anohana: The Flower We Saw That Day* (2011), the theatrical film of the same name (2013), and the movie *The Anthem of the Heart* (2015).

Visiting the Production Studio!

At the end of June, with only a little time left before the premiere, we visited the studio where *your name.* was being made. How were those elaborate, delicate visuals created? We'll show you around the work site and the production process!
(Text: Motoki Kurata Photography: Mikio Shuto)

In the art and composition areas, the room lights are kept rather dim to avoid the effects of reflected light on the monitors.

Art Team

The array of envelopes lined up on the shelves hold art organized by cut. Nearby are piles of the pencils and colored pencils that are indispensible to drawing. There are a variety of different leads, just in case.
(Sign: Orders for composition dept.)

Composition Team

In the photography department, each staff member works with two monitors. The vertically oriented monitors are set up that way to make it easier to view the time sheet (written instructions about dialogue timing and directions for camera work) while they build each shot.

When you enter the studio, it's almost silent; you'd never think there were more than twenty staff members present. It is crunch time, after all, right before the completion of the film, and everyone is engrossed in their work. In the open space in the center of the room, desks are lined up neatly, with the "art department" closest to the door, the "composition department" in the middle, and the "animation department" at the back. All these sections are vital parts of the animation process.

Today, in the animation department, staff members are at work drawing "in-betweens" that transition between the key frames of art that have passed checks by Director Shinkai and Masashi Ando, the art director. The staff members pick up delicate lines, rendering smooth motion at varying speeds.

The animation department is the first step in animation production. Many of the notes from the director on correction forms had to do with subtle emotional movements, such as "Starting with this cut, I want to show a slightly stronger expression."

Animation Team

This unique "Shinkai World" is the result of the director's personal care in giving detailed instructions throughout every work process.

Director Shinkai in discussion with a staff member as he checks a visual in production. Storyboards and reference materials are piled around the desk to keep them easily accessible.

Director Area

The art department is the department that produces the background art. For *your name.*, a staff led by directors who have helped create the art since *The Place Promised in Our Early Days* maintain the quality of the beautiful backgrounds that are an irreplaceable part of Shinkai films. The role of the composition department is to put these things together and complete the movie. Not only do they add what's known as "Shinkai magic"—such as atmospheric effects and light—they do something that isn't normally done: adjusting the colors of the cels to make them feel more integrated with the backgrounds and the lighting.

One big difference between this and an average animation production studio is that Director Shinkai himself participates in the composition process, helping to finish the film. As you can see, the movie *your name.* was created through the meticulous work by all departments.

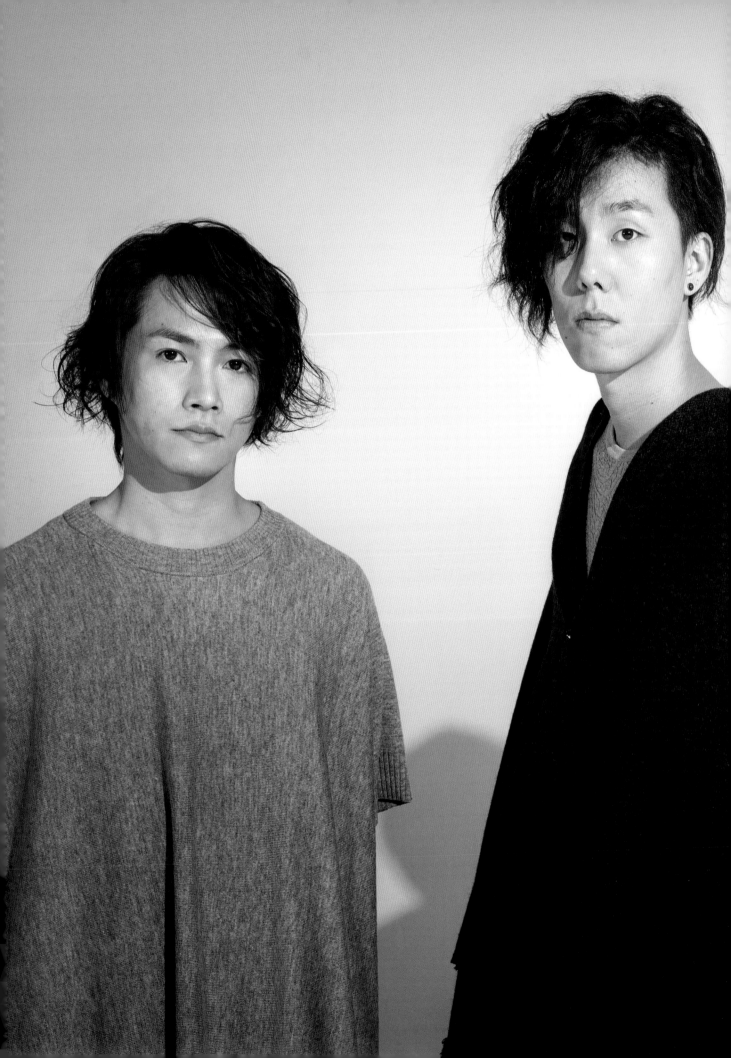

RADWIMPS

Interview

Due to a heartfelt request from Director Shinkai, the band
RADWIMPS was put in charge of the film's theme and soundtrack,
and their music feels like an essential part of the film. How did
those songs come to be?

(Text: Motoki Kurata Photography: Mikio Shuto)

The promise
exchanged
with Director
Shinkai: Be
straightforward,
don't run, and
tackle it head on.

The initial anticipation of a coming adventure

—From what I hear, one of the things that led to your participation in this film was Noda's acquaintance with planner and producer Genki Kawamura.

Noda: That's right. In the autumn of the year before last, Kawamura texted me. Apparently, when he and Director Shinkai were discussing what to do for the music of *your name.*, the director had mentioned RADWIMPS as a band he liked. So then I got a text asking if I'd meet with him, and a few days later, we actually met.

—How did you feel at the time?

Noda: Incredibly nervous. (laughs) However, my impression of Director Shinkai was that he was very kind, and he chose his words carefully as he spoke.

—At that point in time, how far along in the production process was the film itself?

Noda: It was still just a script. With only words to go on, it was a little hard to understand, and I couldn't get a handle on the overall picture. However, from the explanation the director gave me, I understood that he was aiming for something a step or two beyond his previous works. I remember my sense of anticipation, a feeling that this was going to be an interesting adventure.

—Takeda and Kuwahara, what did you think when you heard about the offer?

Takeda: I love anime, and I'd seen all of Director Shinkai's films since *Voices of a Distant Star*. So at first, I was really startled. "Huh? Does this stuff actually happen?" (laughs)

Kuwahara: I was happy, too, but to be honest, I couldn't really get my head around the situation. In the first place, for our very first preliminary meeting with the director, we got called to this absolutely gigantic conference room at the record company. That startled me right off the bat. (laughs) The director showed us early footage and told us, "I'd like this sort of music here," and "We'll need about twenty-six pieces of music in all," but I couldn't process the information at that speed, and somewhere in the middle, my brain just stalled. (laughs)

Noda: Yeah, it was a three- or four-hour meeting, and neither of these guys said a single word. I got mad at them after that, obviously. "Are you two actually into this or not?" (laughs)

Takeda: Well, Yojiro had told us about it in advance, but we hadn't expected it to be quite that big a deal. (wry smile)

Noda: I'd like to watch a "making-of" documentary of that meeting. I bet you'd be able to see those two gradually starting to sweat. (laughs)

"The lyric 'We'll struggle magnificently' is full of everything I sensed in Taki and Mitsuha."
(Yojiro Noda)

RAD's music blends well with the worlds the director creates

—There are four songs with vocals; how did you go about composing those?

Noda: At first, based on the script and what we got out of that preliminary meeting with the director, we got about three or four songs into shape. That was last February. They weren't really finished yet, but there are fragments of them in "Zenzenzense" and "Sparkle."

—So there were always going to be four songs, from the beginning?

Noda: They didn't give us a specific number, but I got the sense the director had always wanted to include a lot of songs with vocals.

Kuwahara: When they showed us the storyboard, there were memos stuck on it with titles of existing RADWIMPS songs and notes that said "Use a song that feels like this one in this scene." I could tell he had a really clear vision for it.

—Then, when you were writing the songs, did the director give you specific concepts to work with?

Noda: No, that didn't happen. I think he didn't want to make things concrete for us and narrow the limits on our creativity. Besides, we heard a lot about his enthusiasm for RAD's songs. For example, the director said, "When something expands from our small world out into the universe in an instant, then returns, you get this incredible feeling that I love." I thought that felt a lot like the worldview in the films the director makes, and it seemed as though it was our job to pick up on the music he wanted from conversations like that.

Kuwahara: Come to think of it, the director himself said, "The lyric that comes up in the RAD song 'Futari-goto'— 'We'll use our once-in-a-lifetime warp here'—links to the worldview of this film," didn't he? When I heard that, I began to understand why we'd been called for this movie.

Takeda: Plus, I think Shinkai's and Yojiro's sensibilities—or maybe, the roots of their attitudes toward creative works—are pretty similar. They're also extremely similar in that they're both stubborn. (laughs)

—Being on the same wavelength as the director would be a big advantage when writing the music, it seems.

Noda: It was. It wasn't easy, though; there were difficulties as well.

—Can you give an example?

Noda: There are way too many; I can't narrow it down. (laughs) In terms of vocal music, we made about twelve demos in all, and those were ultimately pared down to these four songs. The remaining eight simply didn't fit the image the director had, so they got the boot. But the director frequently told us, "I want you to be straightforward. Don't run, don't lose focus, and tackle it head on." That was because, at first, I'd made some songs with English lyrics as well. I thought it might be a good idea to add color to the film from various angles. However, the director saw it as a form of running away. It's true that, somewhere inside, I did feel a little uncomfortable about competing with perfectly straight pitches. On top of that, I have my own sense of aesthetics, and I tried to dress the songs up a little, make them a little more trendy. But every time I did, the director would encourage me to do better. "Would you take one more firm step forward?" he'd say. Sometimes I'd wonder, "What exactly is this relationship?" (laughs) What made my heart skip a beat, though, was that one time he said to me, "Even if you have to do something you consider embarrassing, Noda, you could never lose your dignity." It was a huge shock, like he'd seen right through me. That comment was like a lifeline; thanks to that, I managed to compose all the way to the end without hesitating.

Actually remaking the anime to allow the lyrics to be heard

—Did you do several rewrites on the lyrics as well?

Noda: The director made almost no requests for corrections to the lyrics.

Kuwahara: As a matter of fact, he was incredibly careful with the lyrics. He even animated parts of the movie to go with the songs.

Noda: Yeah, that startled me at first. (laughs) He'd say, "I want people to hear this lyric, so I'm cutting this line," or "I've extended this bit by twenty seconds to make it match the song." Conversely, we worried, "How many more cels is it going to take to extend this by twenty seconds?" (laughs)

Takeda: What startled me most was the change we were told about this February. It was in a tremendously

"When I heard how enthusiastically the director spoke about RADWIMPS, I began to understand why we'd been called for this movie."
(Akira Kuwahara)

important scene, too.

Noda: Oh, yeah, that's right. Near the end of the movie, in the scene where Mitsuha sees the "I love you" that Taki wrote on her palm, "Sparkle" is playing, and there was a big change there. At that point, we'd already finished recording the soundtrack, and we were adding lyrics and changing the arrangement to use the song as an album track. And then, when the director heard the album version, he said, "Let me use these lyrics!" (laughs) We had to correct the soundtrack to match it as well, so we ended up scrambling. (laughs)

Kuwahara: It was rough, but it really showed how much the director cares about music and lyrics. That was fun.

—It seems the director was strongly drawn to many things about your lyrics. In the novelization, he quotes several words from the lyrics. "Struggle, Magnificently," from "Sparkle," is a chapter title, and he also uses "Just a little longer. Just a little more" from "Nandemonaiya."

Noda: Does he?! I didn't know that. That's great to hear.

—In particular, the phrase "Just a little longer" offers a worldview full of the promise of an ending of some sort; he said it made him realize that was what he'd wanted to show.

Noda: I see... Still, I think it's true that the fleeting sense in "Just a little longer" is something Shinkai's films and our songs have in common. As if brilliant beauty exists precisely because it's fated to disappear. I think that's a feeling people invariably have, somewhere in their lives; conversely, people who've forgotten that feeling tend to live lazily. That's why even if it does promise an ending, I think it's important to hang on to that sense of "Just a little longer."

—The lyric "We'll struggle magnificently" contains that feeling as well.

Noda: Yes, it does. That lyric is what I ended up with when I put what I'd sensed about Taki and Mitsuha into words. When I see people pursuing something with completely unclouded intentions or genuinely trying to reach an objective with no selfish motives—to me, they're unconditionally beautiful. I felt that strongly in both of them, and I aspire to be like that myself, so I wrote those feelings into the lyrics for "Sparkle."

If we were doing this, we wanted to fight in the same ring as soundtrack professionals

—Kuwahara and Takeda, you wrote music this time as well. What did you keep in mind as you worked?

Kuwahara: Most of the pieces I wrote were for everyday scenes, like the café and Ms. Okudera's theme, so I tried to make something that wouldn't catch the ear too much, that would just slide right on by, in a good way. In addition, there weren't many band-like sounds in the other pieces, so I decided to use a lot of guitar in these.

Takeda: I was the opposite: Most of mine were for scenes like the one where Taki's group goes searching for Itomori. The "gloomy" ones. (laughs) The struggle there was figuring out how to use sound to express those sights and feelings, so I started with a synthesizer and pulled together all the sounds I could think of that struck me as being a little scary.

Kuwahara: We both started by writing music to act as the foundation. Then we had Yojiro listen to it, and finally we got the director's decision on it.

—What were your impressions when you listened to the music they'd created, Noda?

Noda: At heart, they're both honest and straightforward. Maybe that's why they tried too hard to match the movie's worldview in the beginning, to the point where they seemed to be losing sight of our own essence, and so we talked about how to hold on to the reason we were the ones doing this and keep that reason apparent. On the other hand, though, our internal theme was that we really didn't want to write the sort of music that would make people think, "Yeah, this is how soundtracks come out when bands write them." Since we were doing this, we wanted to fight in the same ring as soundtrack experts, and we figured there wouldn't be much point in doing it any other way. So, to begin with, we got rid of any strange hang-ups and constraints binding us, then simply thought about what melodies and instruments would suit each scene and worked from there.

—Did the director have any requests regarding the sound?

Noda: We heard that he liked orchestration. I'd always been interested in it myself but hadn't had many chances to try my hand at it, so I took the opportunity to test out all sorts of things. We also had a shared awareness that piano would probably be the key overall.

—In which pieces did you pay particular attention to the piano?

Noda: The tenth track on the album, "Date," for one. It plays during Taki's date with Ms. Okudera, so we originally wrote it to sound cheerful. Then the director told us, "There's going to be a scene during this part where Mitsuha is thinking of the two of them and starts to cry before she can stop herself, so keep that in mind as well, if you would." So then we added a slightly melancholic atmosphere with the piano, and the director really liked it. After that, the number of piano pieces just kept growing.

—Did you perform all the piano parts yourself, Noda?

Noda: Yes, I did. I wanted to play the "Date" piece personally, no matter what. But then we worried the sense of unity might disappear if we called in other people for the other pieces, so I did my best.

"Yojiro and Director Shinkai are very similar when it comes to the root of their attitudes toward craftsmanship… And also their stubbornness." (laughs)
(Yusuke Takeda)

Takeda: He really did work hard. What startled me was the time he said, "I'm not really sure I can play this one," and then a few days later he was able to play it perfectly.

Noda: Oh, that's right. Well, by the end, I was just being stubborn about it. (laughs)

Welcome feedback and blunt requests in long e-mails from the director

—What about all this struck you as difficult, Kuwahara and Takeda?

Kuwahara: How particular the director was about music, to no one's surprise. That was really something.

Takeda: We remade it over and over again, didn't we?

Kuwahara: When the director ordered changes after we'd gotten the okay on a piece from Yojiro, the despair was unbelievable. (laughs)

—You had to redo sounds you'd already visualized and start again from the beginning. I would imagine it was hard to mentally shift gears.

Kuwahara: More like impossible. (laughs)

Noda: Halfway through, they whined and groused like you would not believe. (laughs)

Kuwahara/Takeda: Ha-ha-ha-ha-ha-ha!

Noda: First, after we'd written some music, we'd send the director ten pieces or so at a time. Then, after a little while, we'd get back something like a report card.

Takeda: It had these incredibly detailed notes about each individual piece.

Noda: The first half of the text was a looong write-up of his feelings about the piece. He'd compliment us on it, but then there would be an abrupt switch, and the last half would be nothing but blunt requests. (laughs) And the cycle would repeat about twenty times, so we gradually lost track of what was going on. (laughs)

Kuwahara: Seriously, at the end, the notes got hard to understand. We all went over them together and asked each other, "What do you think this means? Is he saying it's okay? Or are we supposed to do it over again?"

Takeda: After all, people interpret things in different ways, and if we got the wrong idea, we'd just be making things even harder on ourselves.

—I see… For a long time, then, it felt as if there was just no end in sight.

Noda: The director is the sort of person who wants to get all his feelings across, so the letters ended up being long, no matter what he did. Meanwhile, since we were never sure whether a piece was going to get kicked back to us again, we got more and more depressed about opening e-mails from him… (wry smile) Oh, but come to think of it, we did push back on his pushback, too. We told him, "We're absolutely positive that this piece is the one for this scene!" and he let our take on it stand.

—You couldn't take that much time over something and hash out the nonnegotiable points if you didn't trust each other.

Noda: True. Of course, as we were working, the numbers on our "irritation" meters did go up from time to time. (laughs) Still, at the same time, our "happy" and "grateful" meters went up as well. Plus, at the very, very end, the director's enthusiasm overcame all that and filled us with excitement. No matter how hard things got, we were psyched up and ready to do this.

—Now that you mention it, I hear Takeda and Kuwahara went to watch the actors' recording session, and you recorded vocal performances while you were there.

Kuwahara: That's right. Although I'm pretty sure you'll never notice us. (laughs)

Takeda: We played the high school guys in the classroom who said things like, "They're doing a concert soon, aren't they?" and in the last half when the power's gone out in Itomori, we're firemen who say, "What's goin' on?" and "So we stay put?" The scenes were just a few seconds long, but it took us over thirty minutes. We were seriously tense. (laughs)

—In closing, then, tell us what you thought when you saw the finished movie.

Takeda: It gave me goose bumps the whole time. I wanted to recommend it to a whole lot of people. It's a film you want other people to see.

Kuwahara: It really affected me, too, and not because I'd worked on the soundtrack. I cried.

Noda: In an era like ours, when everyone wants to toss out their opinions on a whim, I think it takes serious resolve to write a love story this straightforward. I got a strong sense of Director Shinkai's unwavering core strength and enthusiasm that gave it shape. I also thought that this very uniqueness means it's needed in these times. I hope all sorts of people enjoy it, music included.

New Album
Your Name
RADWIMPS' first soundtrack album. It contains twenty-seven tracks, including the vocal tracks "Zenzenzense (movie ver.)," "Dream lantern," "Sparkle (movie ver.)" and "Nandemonaiya (movie edit./movie ver.)" The limited edition comes with a special interview with director, Makoto Shinkai, and the band members, footage of the recording sessions, a solo piano concert featuring "Mitsuha's Theme" and "Autumn Festival" performed by Yojiro Noda at the studio, and more.

Regular Edition:
CD only
¥2700 + tax

First-Press Limited Edition:
CD + DVD + Book
LP size ¥6400 + tax

RADWIMPS

Yojiro Noda (vocal/guitar/piano), Akira Kuwahara (guitar), and Yusuke Takeda (bass). The band formed in 2001, then made their major debut in 2005. Their music spans rock, jazz, hip-hop, and folk and can't be confined to any existing genre, while their lyrics deal with everything from romance to views on life and death. Their reputation spread through word of mouth, and they've won great support particularly among the younger generation. In 2015, ten years after their debut, they performed a successful concert with no supporting acts at Makuhari Messe for an audience of over 300,000.

"The fleeting sense in 'Just a little longer' is something Shinkai's films and our songs have in common." (Yojiro Noda)

Arata Kanoh
Interview

Arata Kanoh participated in *your name.* by providing script assistance, and his deep knowledge of the film's essence is second only to Director Shinkai's. He told us all about the side stories he wrote, complete with behind-the-scenes production anecdotes.

(Interview/Write-up: Motoki Kurata)

Arata Kanoh
Original Story: Makoto Shinkai
Cover Illustration: Masayoshi Tanaka
Interior Illustration: Hiyori Asahikawa

Resurrecting ideas cut from the script

—To start, could you tell us how you came to write *Another Side*?

Kanoh: It started when an editor from Kadokawa asked me, "Would you be interested in releasing a side story?" I'd been involved with *your name.* since the early stages; I'd participated in the script meetings, and I wrote the first rough script based on Shinkai's synopsis. However, when Shinkai wrote the final script, several of my ideas were taken out. I wanted to resurrect them, and so I took the opportunity to write *your name.* from my perspective.

—In the book, there are many different scenes and moments that don't come up in the film itself. Did Director Shinkai give you any instructions or opinions regarding the direction of the story in advance?

Kanoh: Absolutely none... Although it might have been funny if we'd gone at it hammer and tongs. "That part isn't like this!" "But the intention was there!" (laughs) When Shinkai decides to leave a novelization to someone else, he almost never cuts in. CoMix Wave Films, the production company, is also unique. They told me, "We want you to put in tons of original elements." I don't know of many production companies like that. (laughs) Still, doing it that way really does expand the work, so I think it's the right mindset. It's fun for me personally, since it lets me put in all sorts of ideas, and I wish more companies would follow their example. (laughs)

—It may also have been because you'd been involved with the script since the early stages, and they trusted you. In that case, did you have quite a lot of freedom when it came to actually writing the book?

Kanoh: I did. However, before I started writing—I wouldn't call it "preparation," exactly—I read Shinkai's novelization of the film, which he'd already finished. Then, since his book developed its story around Taki and Mitsuha, I hit on the idea of making the side stories focus on the people around them without changing the established story. To put it another way, Shinkai had written a "5-7-5" haiku, and I added a slightly playful "7-7" couplet to it.

Tesshi's gloom is a mirror that reflects the essence of Itomori

—The spin-off novel is made up of four stories, written from the perspectives of Taki Tachibana while he's living as Mitsuha; Mitsuha's friend Katsuhiko Teshigawara; her little sister, Yotsuha; and her father, Toshiki Miyamizu. Was it your idea to focus on these characters?

Kanoh: In the first plot proposal I came up with, there was a story about Ms. Okudera as well. However, I heard from someone at CoMix Wave Films that Shinkai had a strong preference for Tesshi, so in the end, I settled on these four. I only remembered it then, but Shinkai actually had been very careful with what Tesshi said and did from the time we were drafting the script. For example, in the scene where Mitsuha and Sayaka are lamenting that Itomori has nothing, he scolds them: "Geez, y'all!" On the other hand, when Sayaka asks him, "What are you going to do in the

According to Kanoh, "there's a lot about Taki that's shrouded in mystery, but he's definitely not a complicated person." That personality comes through in the novel as well.

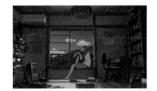

Director Shinkai was particular about showing all the wireless radios in Tesshi's room. In the spin-off novel, they're a more important element than they were in the film.

In the movie, it's Yotsuha's job to be the straitlaced foil for Mitsuha's strange behavior, but in the spin-off, her internal worry for her big sister is shown in detail.

Toshiki left the Miyamizu family to become mayor. In the film, not much is said about his thoughts, but the spin-off shows his feelings for his family and for the deceased Futaba.

future?" his answer is vague and noncommittal. Shinkai said both of these lines and actions are important in showing what sort of town Itomori is. That conversation had sort of stuck with me, so I dug deeper into that theme when I wrote.

—None of those four stories are from Mitsuha's perspective. However, Mitsuha invariably appears in each episode, and the stories view her subjectively from multiple angles. That structure struck me as interesting as well.

Kanoh: At first, I wasn't trying for that. (laughs) However, as I wrote, it occurred to me as well: "I see; these are stories about the people around Mitsuha thinking a variety of things about her." Not only that, but the image each of the four has of Mitsuha is different, and it's written so that even if you look at all the stories together, her full personality won't appear. As a result, the question persists: "What is this girl anyway?" I thought that structure was interesting. (laughs)

Shinkai films are open to interpretation; this novel is merely one example

—Could you tell us what you kept in mind when writing each story?

Kanoh: For Taki, I wanted to portray the comedy elements that crop up when guys and girls switch bodies. In the movie, there's a scene where he's playing basketball and Mitsuha's chest bounces dramatically and all the guys stare, but aside from that, there's almost nothing about how he handles changing clothes at school, or further yet, about how strange it feels to move in her body. Still, I'm a bit of a stickler for these things. "If it's a body-swap movie, *this* and *that* have to be in it!" (laughs) I put lots of that into the initial script, but it got cut because, as I was told, that wasn't the film's main focus. I thought that was a shame, so in the spin-off, I ended up writing all the lowbrow stuff I wanted. (laughs) In the second story, as I mentioned earlier, I write about Tesshi's gloomy feelings regarding Itomori. In addition, he believes Mitsuha when she says the comet's going to fall and helps with her wild plan, but we were only able to show very briefly his thoughts and emotions that explain why he'd go that far for her, and so I added a few supplementary lines to flesh out the picture.

—He did come across as very manly.

Kanoh: Yes, Tesshi's got a really good nature. He's a good judge of people, he's smart, and even at his age he's trying to see the truth of things. However, in the second story, I raised his stock a bit too much, so in the third story, Yotsuha's rather harsh opinion of Tesshi is there partly to balance things out. (laughs)

—In that third story, Yotsuha drinks her *kuchikamisake* and forms a small link with the past.

Kanoh: Since Yotsuha is a member of the Miyamizu bloodline as well, she's bound to have the power to see dreams the way Mitsuha and her grandmother Hitoha did. I wanted to show just a glimpse of that here.

—And the final story is about the most mysterious character of all: their father, Toshiki.

Kanoh: That story had its origins in my desire to clearly present the character's background to readers: why the father—formerly a folklorist—became the chief priest at Miyamizu Shrine, why he was currently living apart from his family, and why he'd become the mayor. To tell you the truth, Shinkai's synopsis didn't cover these things in detail, either. For that reason, I came up with what was very nearly an original story for his background, starting with the time when he met his wife, Futaba, up until he became mayor.

—The way he has held on to the memory of his deceased wife all this time seems very appropriate for a Makoto Shinkai film.

Kanoh: "Constantly searching for someone" is a theme nearly all Shinkai films have in common, and in *your name.*, Mitsuha and Taki are the ones it applies to. In this spin-off, though, I gave that theme to Toshiki and Futaba as well. That's why in that last scene, when he sees the shadow of his wife in Mitsuha when she appears at the town hall, the nuance more strongly implies a reunion with a beloved rather than an interaction between father and daughter.

—I see. From this spin-off and from what you've told me, I think I've gained a better understanding of the other side of the story.

Kanoh: Thank you. I do want to mention, though, that what I've written in these side stories isn't the "right answer."

—What do you mean?

Kanoh: None of Shinkai's films tell a lot. By venturing to leave blanks, they let the audience fill in those spaces. In other words, everyone's interpretation is different, and that's natural. This novel is also simply what Arata Kanoh thinks the answers are. So when you see the film, I'd like you to value your own feelings and interpretation first. After you've done that, go ahead and read this spin-off as just another possible way to view the story.

your name. Another Side:Earthbound
Author: Arata Kanoh Original Story: Makoto Shinkai
Cover Illustration: Masayoshi Tanaka
Interior Illustrations: Hiyori Asahikawa
Kadokawa Sneaker Bunko

A spin-off novel based on the film's story, written from the perspectives of the people around Mitsuha. It's made up of four stories, beginning with Taki's troubles while living as Mitsuha, and also including the feelings of her classmate, Katsuhiko Teshigawara, and her little sister, Yotsuha. In addition, it clarifies relationships and background details that aren't revealed in the film, such as how Mitsuha's father, Toshiki, and mother, Futaba, met and the origins of Miyamizu Shrine. A must-read for fans.

ARATA KANOH

A native of Aichi Prefecture. After working as a freelance editor, he debuted as a writer in 2002. He's written the novelization of *Hayate the Combat Butler! Heaven Is a Place on Earth* and for the *Shining* game series. He participated in the scenario development of the *your name.* film and has worked on other novelizations for Shinkai films: *5 Centimeters Per Second: one more side*, *Voices of a Distant Star: Words of Love/Across the Stars*, and *The Place Promised in Our Early Days* (all published by Enterbrain).

The names "Mitsuha" and "Itomori" are already in place…
Mini Interview with Makoto Shinkai:

The Initial Proposal

The title on the initial project proposal for *your name.* was *Had I Known It Was a Dream (Temp.)—A Boy/Girl Torikaebaya Tale*. We're releasing the intriguing content of that initial proposal just for this book, along with Director Shinkai's original idea!
(Text: Mizuo Watanabe)

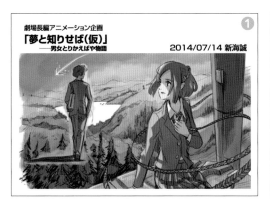

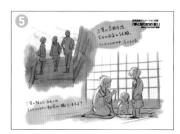

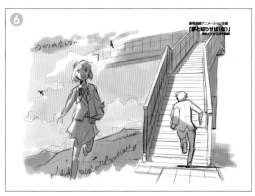
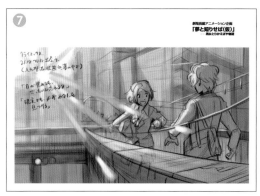

The initial project proposal was based on ideas I got from Ono no Komachi's "Had I known it was a dream, I would not have awakened" *waka* poem and from *Torikaebaya Monogatari*.

At the project proposal stage, the comet, braided cord, and Itomori motifs are present already. The heroine's name was already Mitsuha in that initial proposal as well. I'd decided there would be a big lake in Itomori, and water (*mizu*) was going to play a key role in the story, so I wanted to give the characters names that had ties to water. "Mitsuha" comes from the name of a water god, Mizuhanome. The name Miyamizu is also related to water, and "Taki" got his name from the connotations of waterfalls and dragons that it holds. I realized later that his name had turned out similar to Takaki's from *5 Centimeters Per Second*, but it's a complete coincidence, and I'd forgotten all about it when I named him. (laughs)

As a matter of fact, *your name.* is a retelling of *The Place Promised in Our Early Days* as well, in a way. *The Place Promised* is a film that many people are kind enough to love even now, but it was the first story with significant volume that I'd worked on; I couldn't seem to get the script into the shape I wanted, and I'd experienced setbacks when writing the scenario and producing the story. I'd studied scriptwriting over again from the beginning, which helped me think I'd finally be able to write a deeper, more entertaining story, and that's what allowed me to create *your name.* I was conscious of that back when I made the initial project proposal.

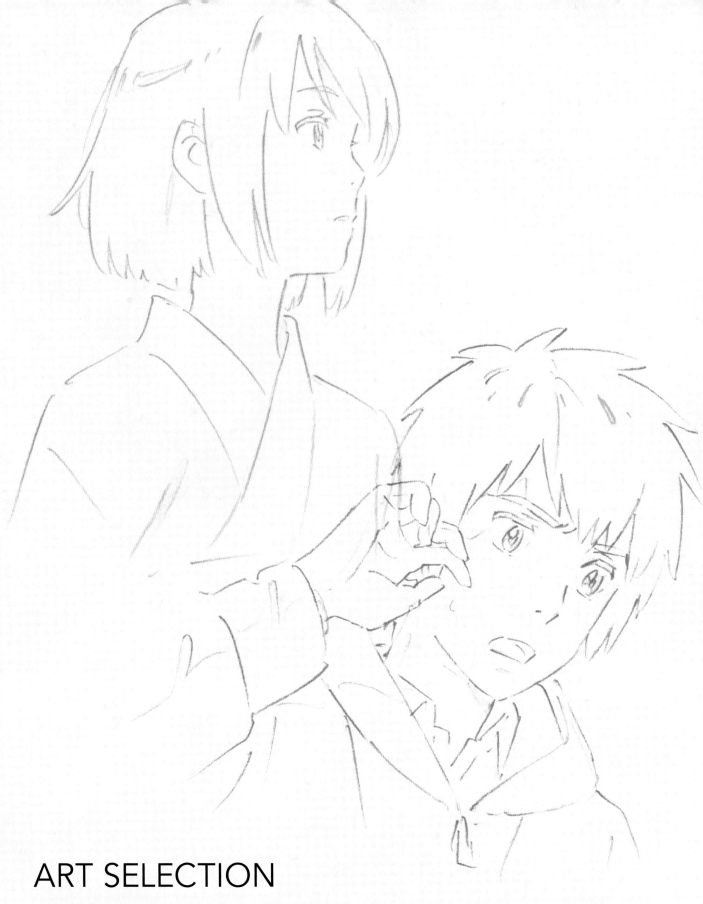

ART SELECTION

This is the beginning of the film art section. It's bursting with character designs by the art director, Masashi Ando, the art designs that set the stage of the film, accessory designs, storyboards drawn by the director, beautiful background art, and more!

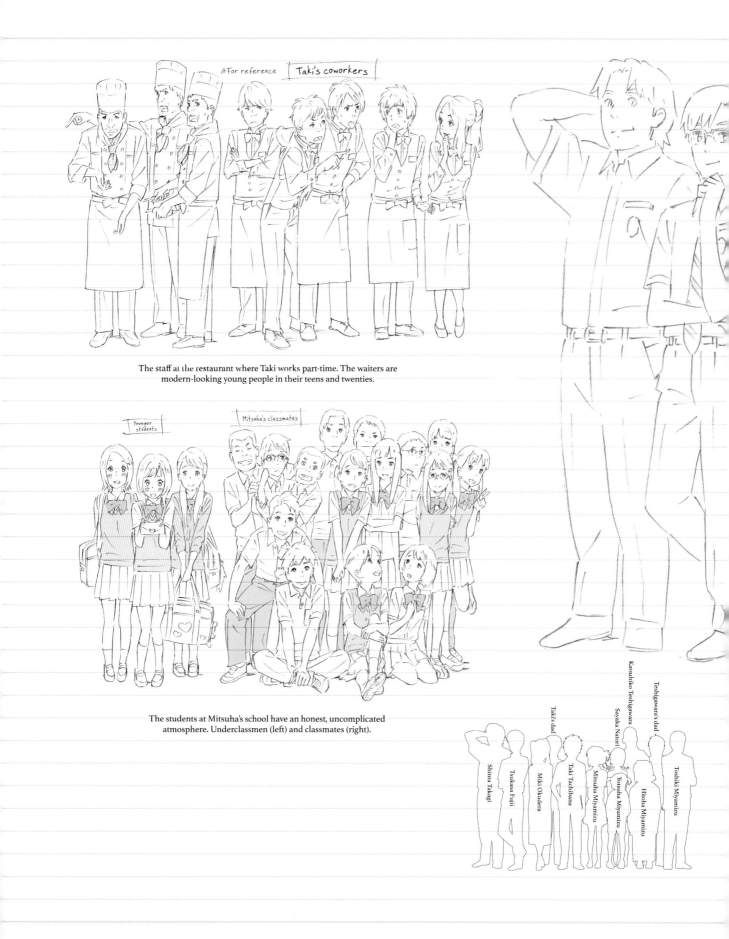

For reference　Taki's coworkers

The staff at the restaurant where Taki works part-time. The waiters are modern-looking young people in their teens and twenties.

Younger students

Mitsuha's classmates

The students at Mitsuha's school have an honest, uncomplicated atmosphere. Underclassmen (left) and classmates (right).

Shinta Takagi

Tsukasa Fujii

Miki Okudera

Taki's dad

Taki Tachibana

Mitsuha Miyamizu

Katsuhiko Teshigawara

Sayaka Natori

Yotsuha Miyamizu

Teshigawara's dad

Hitoha Miyamizu

Toshiki Miyamizu

Comparison
diagram

The main characters of *your name.* are male and female, young and old.
There's a sense of familiarity about them, as if you might find them in any town.

CHARACTER GUIDE

These aren't devices that exist simply to move the story along. They're individual people, living their own lives in their own ways.
Characters with all sorts of appearances and ways of expressing themselves move vibrantly through the world of *your name.*
Character Sketches: Masashi Ando
Additional Text: Hitomi Wada

[Voice: Ryunosuke Kamiki]

立花瀧

A high school guy who lives in a condo with his dad in downtown Tokyo. He's a little quick to fight, but he's enjoying his time in high school with his good friends, Tsukasa and Takagi.

After school, he stops by cafés and works part-time at an Italian restaurant.

He secretly likes Ms. Okudera, a college girl he works with, but he's a late bloomer when it comes to love. He's interested in architecture and art, and he has lots of books about both fields in his room at home.

TAKI TACHIBANA

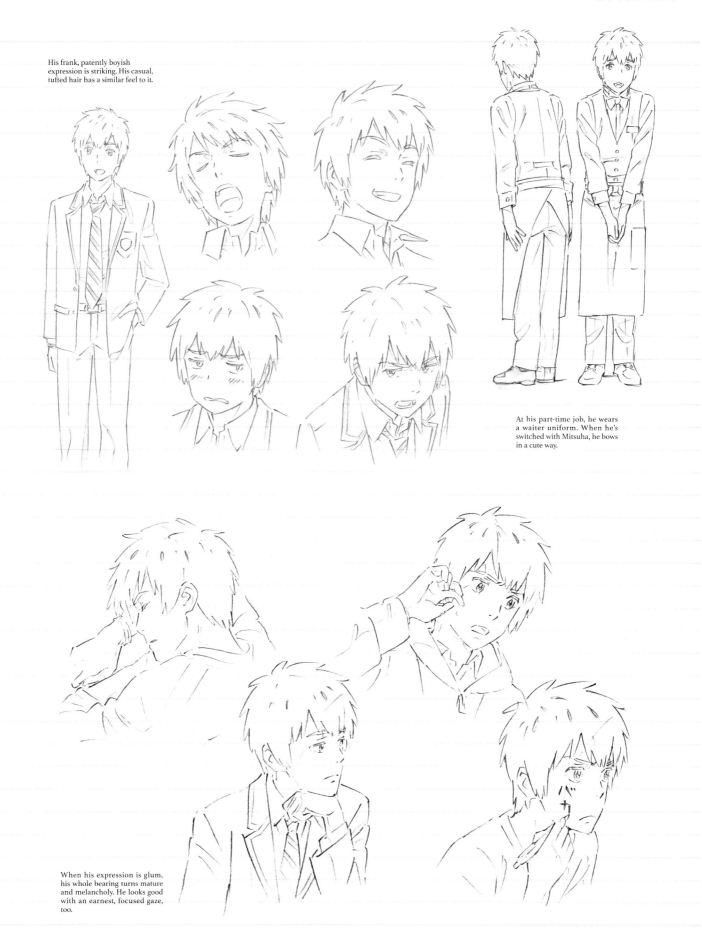

His frank, patently boyish expression is striking. His casual, tufted hair has a similar feel to it.

At his part-time job, he wears a waiter uniform. When he's switched with Mitsuha, he bows in a cute way.

When his expression is glum, his whole bearing turns mature and melancholy. He looks good with an earnest, focused gaze, too.

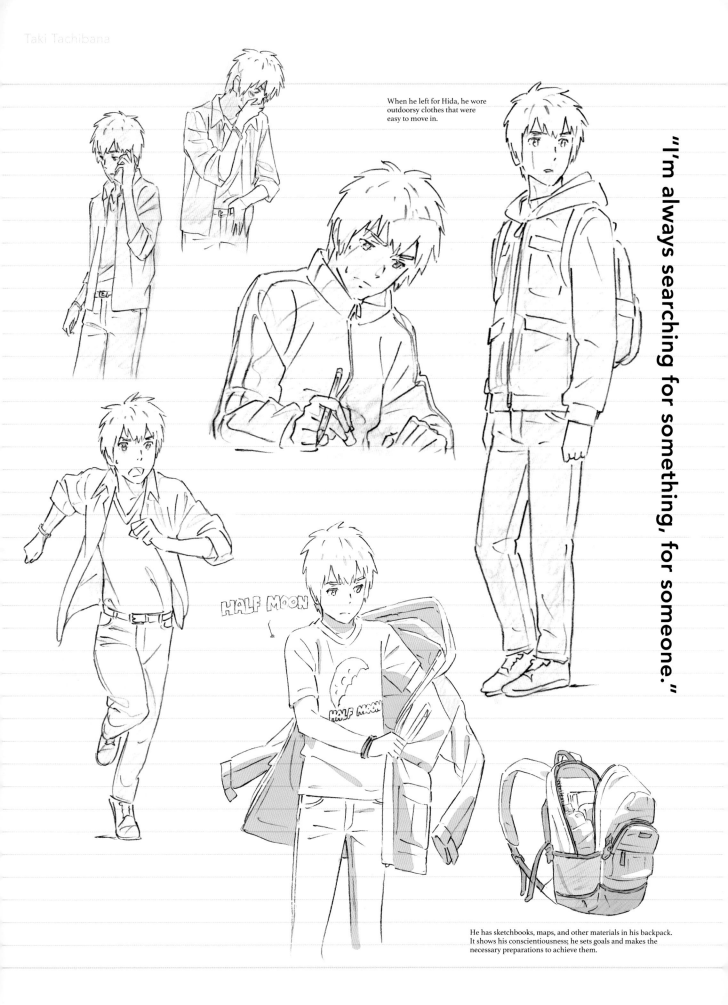

When he left for Hida, he wore outdoorsy clothes that were easy to move in.

HALF MOON

"I'm always searching for something, for someone."

He has sketchbooks, maps, and other materials in his backpack. It shows his conscientiousness; he sets goals and makes the necessary preparations to achieve them.

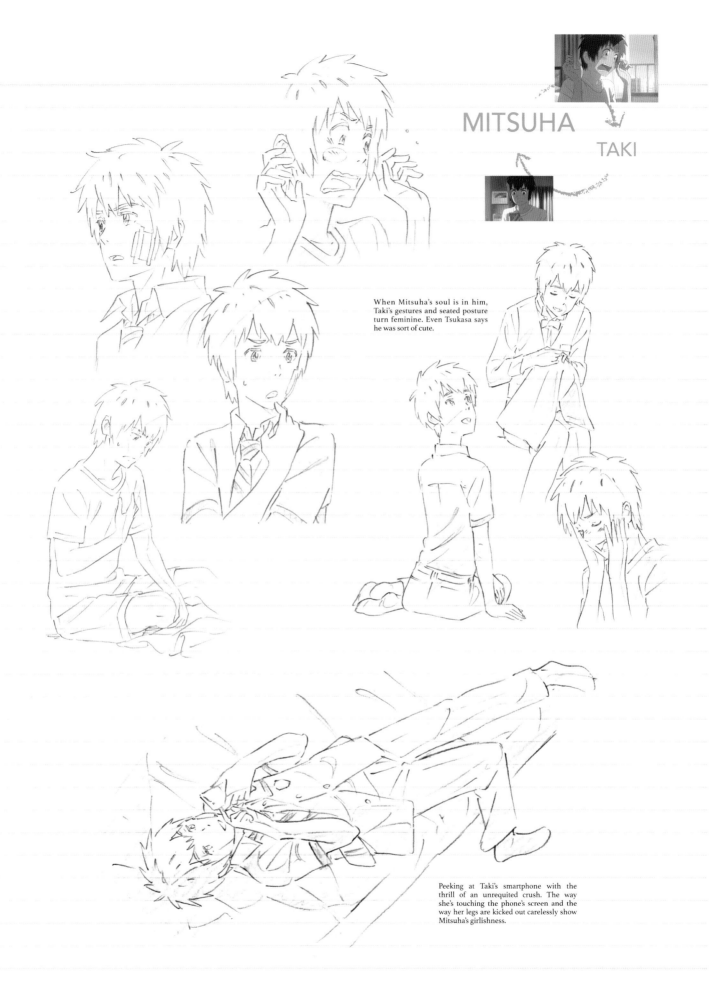

MITSUHA

TAKI

When Mitsuha's soul is in him, Taki's gestures and seated posture turn feminine. Even Tsukasa says he was sort of cute.

Peeking at Taki's smartphone with the thrill of an unrequited crush. The way she's touching the phone's screen and the way her legs are kicked out carelessly show Mitsuha's girlishness.

 [Voice: Mone Kamishiraishi]

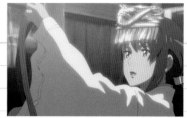

宮水三葉

MITSUHA MIYAMIZU

A high school girl who lives in Itomori, a rural town deep in the mountains.

She was born into the family that administers Miyamizu Shrine, and she lives with her grandmother Hitoha, who is also a Shinto priestess, and Yotsuha, her little sister. Her mother, Futaba, passed away due to illness, and Toshiki, her father and the town's mayor, has left the family.

As a shrine maiden who serves Miyamizu Shrine, she makes braided cords, performs sacred dances in religious rituals, and carries out her role responsibly. However, she bemoans the small and stifling size of the town, which doesn't have a single café, and she longs for a colorful life in Tokyo.

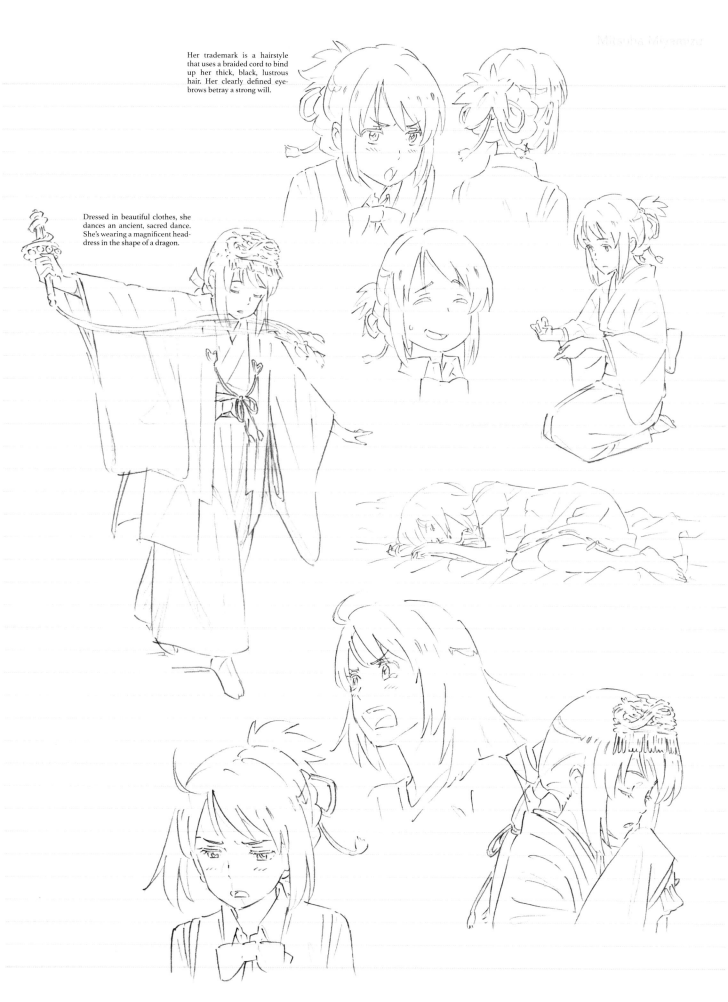

Her trademark is a hairstyle that uses a braided cord to bind up her thick, black, lustrous hair. Her clearly defined eyebrows betray a strong will.

Dressed in beautiful clothes, she dances an ancient, sacred dance. She's wearing a magnificent headdress in the shape of a dragon.

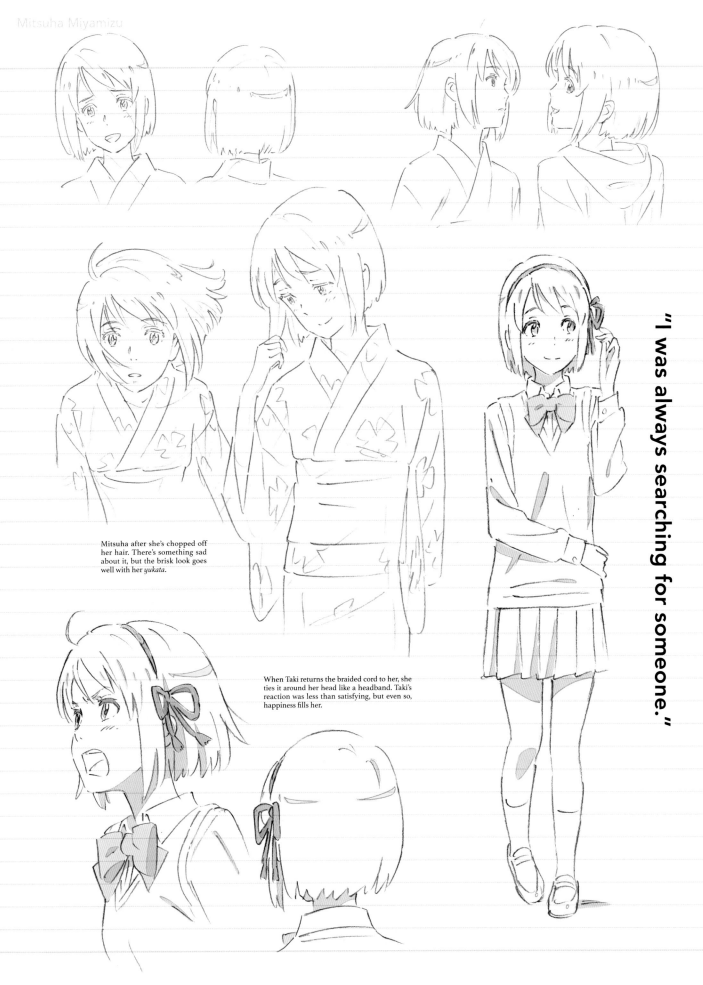

Mitsuha after she's chopped off her hair. There's something sad about it, but the brisk look goes well with her *yukata*.

When Taki returns the braided cord to her, she ties it around her head like a headband. Taki's reaction was less than satisfying, but even so, happiness fills her.

"I was always searching for someone."

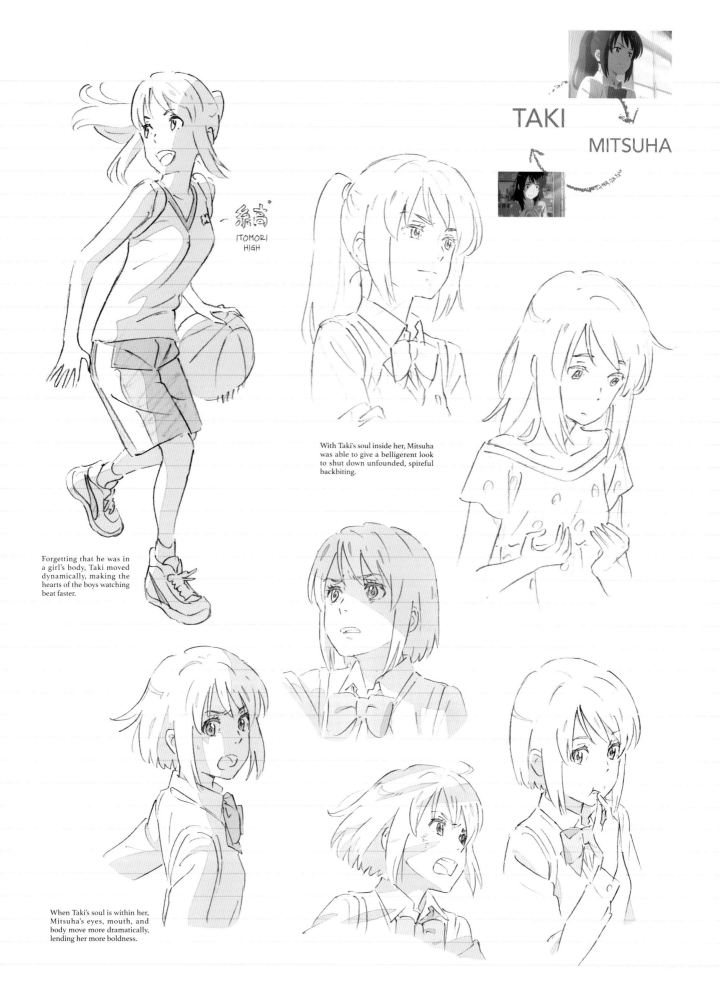

ITOMORI
HIGH

TAKI

MITSUHA

With Taki's soul inside her, Mitsuha was able to give a belligerent look to shut down unfounded, spiteful backbiting.

Forgetting that he was in a girl's body, Taki moved dynamically, making the hearts of the boys watching beat faster.

When Taki's soul is within her, Mitsuha's eyes, mouth, and body move more dramatically, lending her more boldness.

MIKI OKUDERA

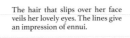

[Voice: Masami Nagasawa]

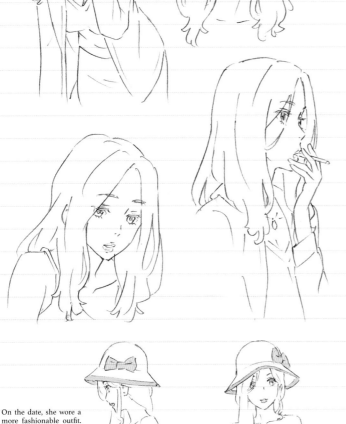

The hair that slips over her face veils her lovely eyes. The lines give an impression of ennui.

A senior employee at the restaurant where Taki works part-time. She's a beautiful, stylish college student, and Taki and the other guys idolize her. She was drawn to Taki's earnest diligence when Mitsuha's soul was inside him, and they got closer. She and Tsukasa went with Taki on his trip to Itomori.

On the date, she wore a more fashionable outfit. Her clutch bag and off-the-shoulder blouse are sexy.

BAG

Comment from Masami Nagasawa

I've done a few voice-acting jobs before, but it's still hard for me. There were aspects of it I hadn't been able to grasp in the past, so I was glad for the opportunity to give it another try. Since I was playing a more experienced character who everyone idolized, I tried to bring maturity, kindness, and a little sexiness to the role. I was deeply touched by the gradual stirring of Taki's and Mitsuha's hearts, and I cried at the sad parts. The visuals were really beautiful as well; realistic things mingle with nonrealistic 2-D things, and even as you experience your own present-day world, you feel as if you're diving into a fantasy. I really enjoyed that about the film.

Masami Nagasawa • Born June 3, 1987. In 2000, she won the grand prize at the fifth Toho Cinderella audition. She has worked as a voice actor in the animated films *From Up on Poppy Hill* (2011) and *Yo-kai Watch: the Movie 2* (2015).

HITOHA MIYAMIZU

[Voice: Etsuko Ichihara]

Mitsuha and Yotsuha's grand-mother and currently the Shinto priestess at Miyamizu Shrine. Because she lost her daughter, Futaba, to illness and her son-in-law, Toshiki, left the family, she's raised Mitsuha and Yotsuha on her own. She protects the shrine, teaching her granddaughters about Itomori's millenium of history and traditions that have been passed down for generations.

The Miyamizu family is used to wearing traditional kimonos. Each woman looks elegant, wearing a kimono and obi that suits her.

Carried on her granddaughter's back, Hitoha looks rather happy.

Comment from Etsuko Ichihara

When I saw how unsteady these young people were and how they struggled to clearly grasp the path they were on, I wondered whether it reflected the situation of today's youth, and the thought saddened me. On the other hand, their passionate hearts yearned so strongly for each other... That feeling was a very precious thing. The journey was exhilarating; I wanted everything to work out somehow, for them to meet and join hands. It was also unusual for me to be working with young people. Everyone did their very best, and none of it seemed artificial at all; they spoke naturally and instinctively, and yet they had definite presence as well. It was good. The world of uncertain sentiments, of longing and unease, was very fresh and new to me.

Etsuko Ichihara • From Haiyuza Theater Company. She has appeared in many works over her long career, including the stage plays *The Threepenny Opera* and *The Chikamatsu Love Suicides*, the movies *Black Rain* and *The Eel*, and the TV series *The Housekeeper Saw It!* She also actively performs vocal roles, including the storyteller in the anime *Manga Japan Folktales* (1975– / MBS), narration, reading aloud, and more.

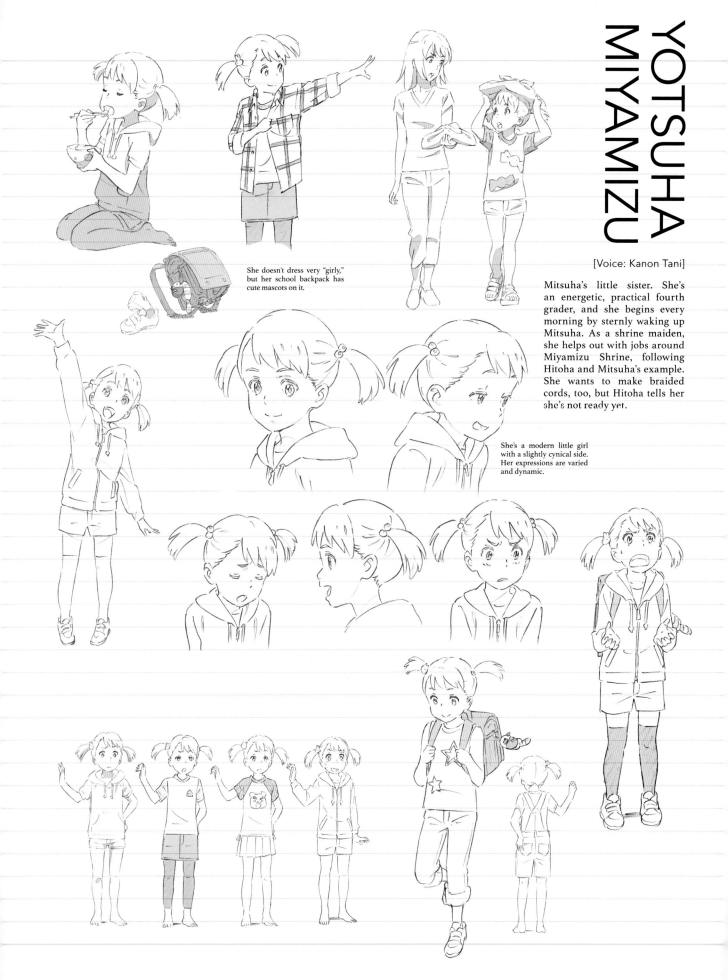

YOTSUHA MIYAMIZU

[Voice: Kanon Tani]

Mitsuha's little sister. She's an energetic, practical fourth grader, and she begins every morning by sternly waking up Mitsuha. As a shrine maiden, she helps out with jobs around Miyamizu Shrine, following Hitoha and Mitsuha's example. She wants to make braided cords, too, but Hitoha tells her she's not ready yet.

She doesn't dress very "girly," but her school backpack has cute mascots on it.

She's a modern little girl with a slightly cynical side. Her expressions are varied and dynamic.

KATSUHIKO TESHIGAWARA

[Voice: Ryo Narita]

Mitsuha's classmate. He's an occult fiend and a machine geek. He has complicated feelings about his dad, who works in the local construction business. He squabbles with Sayaka a lot, but Mitsuha's actually on his mind. His nickname is Tesshi.

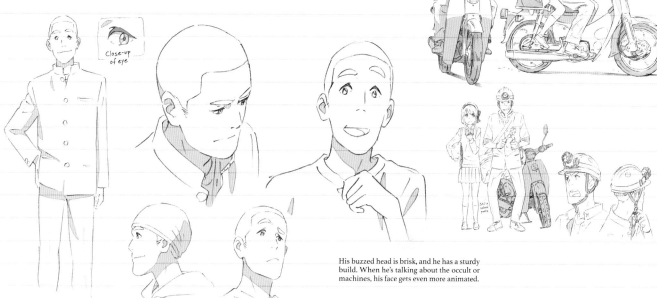

Close-up of eye

His buzzed head is brisk, and he has a sturdy build. When he's talking about the occult or machines, his face gets even more animated.

SAYAKA NATORI

[Voice: Aoi Yuki]

Mitsuha's classmate and childhood friend. She's ladylike but sensible. She has feelings for Teshigawara and squabbles with him a lot. Her older sister is in charge of the local broadcasts at the town hall. Her nickname is Saya-chin.

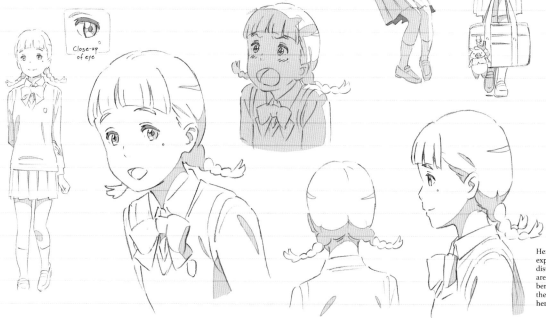

Close-up of eye

Her modest, tranquil expression is cute. Her distinguishing features are the tiny beauty mark beneath her left eye and the rounded curve of her bangs.

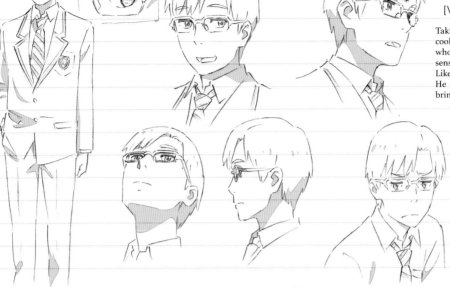

TSUKASA FUJII

[Voice: Nobunaga Shimazaki]

Taki's high school friend. He looks cool, but he's also the sort of busybody who texts Taki and prods him when he senses his friend will be late for school. Like Taki, he's interested in architecture. He crashes Taki's trip to Itomori, bringing Ms. Okudera along.

His neat haircut and glasses make him look intellectual. Behind his glasses, his eyes are kind.

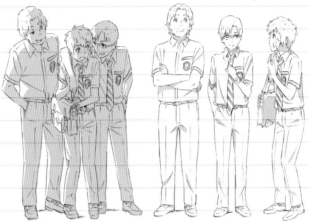

SHINTA TAKAGI

[Voice: Kaito Ishikawa]

Taki's high school friend. Big-boned with a straightforward personality. The type who'd reliably take over a part-time job shift in exchange for a meal. After school, he treks around to different cafés with Taki and Tsukasa.

His solid build and rather thick eyebrows set him apart. He looks good-natured, but he also seems firmly grounded and levelheaded.

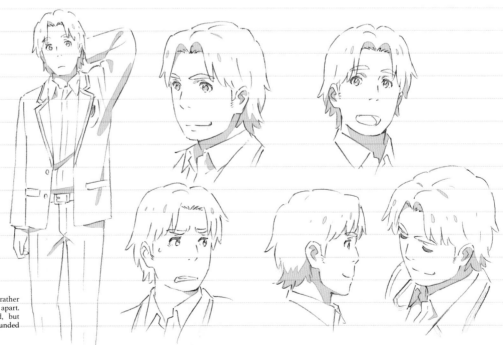

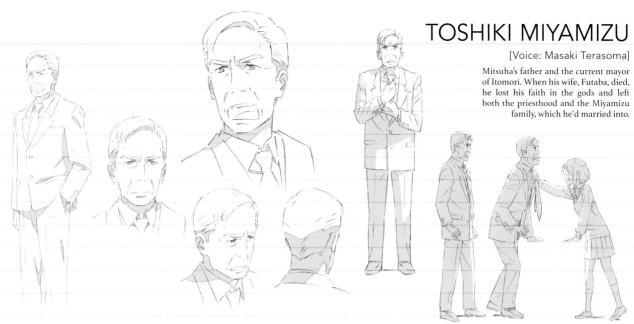

TOSHIKI MIYAMIZU

[Voice: Masaki Terasoma]

Mitsuha's father and the current mayor of Itomori. When his wife, Futaba, died, he lost his faith in the gods and left both the priesthood and the Miyamizu family, which he'd married into.

TESSHI'S DAD

[Voice: Chafurin]

Teshigawara's dad works in the construction business. During election campaign periods, he supports Mitsuha's dad.

TAKI'S DAD

[Voice: Kazuhiko Inoue]

Taki's dad works in Kasumigaseki, and he and Taki live in a condo, splitting the household chores.

MITSUHA'S CLASSMATES

The other kids in Mitsuha's class often make fun of her for being the mayor's daughter and for being a member of the shrine family.

THE RAMEN SHOP COUPLE

Taki met this pair in a ramen shop in Hida. They knew about Itomori, Mitsuha's town, when Taki was searching for it.

ART DESIGN

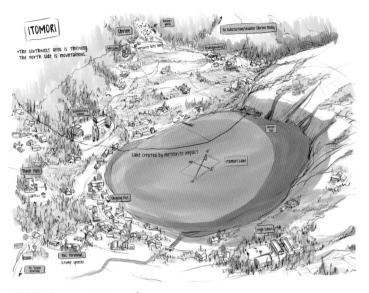

ITOMORI

Itomori is nostalgic and beautiful, a mixture of the sights of old Japan. These drawings provide references for the places within Itomori, such as the relative locations of Mitsuha's house and the shrine, and Mitsuha's room and high school.

000-01 Panoramic View of Itomori
(from early concept board)

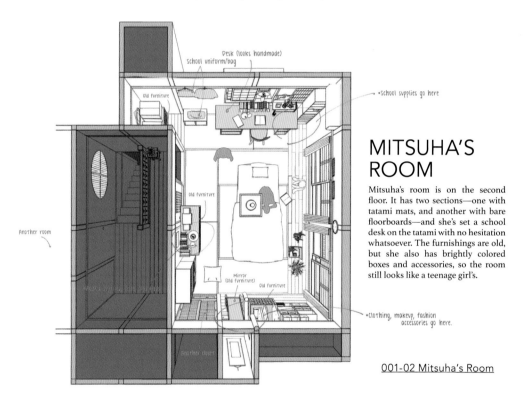

MITSUHA'S ROOM

Mitsuha's room is on the second floor. It has two sections—one with tatami mats, and another with bare floorboards—and she's set a school desk on the tatami with no hesitation whatsoever. The furnishings are old, but she also has brightly colored boxes and accessories, so the room still looks like a teenage girl's.

001-02 Mitsuha's Room

001-02 Mitsuha's Room

001-03 Mitsuha's Room

MIYAMUZU HOME

The living room is where Mitsuha and her family eat. Lots of sunlight pours in, and it's always bright. Unusually for an old house, it has windows that open outward: very stylish. Looking in from the outside, there's a corridor at the back of the room, and the kitchen is on the right.

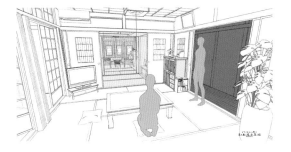

003-01 Miyamizu House/Dining Room

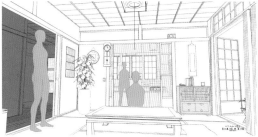

003-02 Miyamizu House/Dining Room

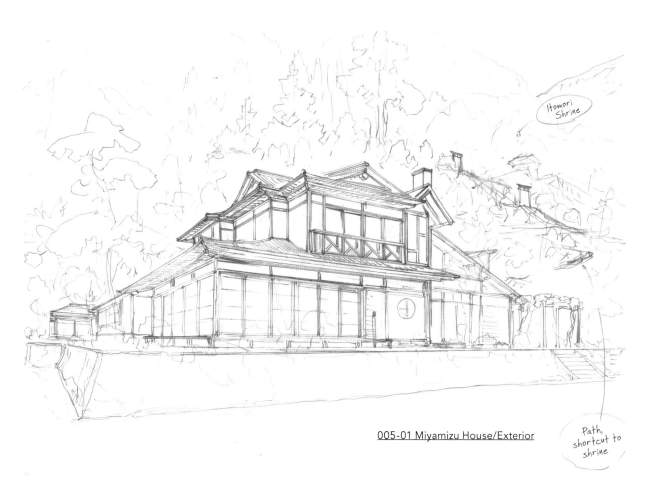

Itomori Shrine

005-01 Miyamizu House/Exterior

Path, shortcut to shrine

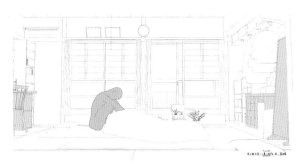

001-04 Mitsuha's Room

001-05 Mitsuha's Room

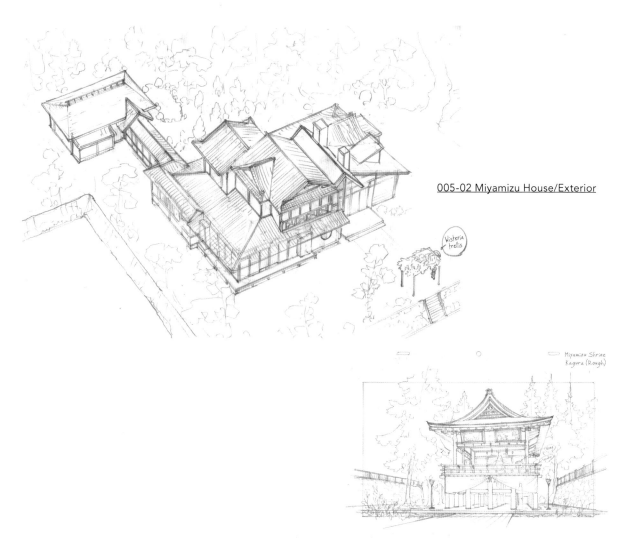

005-02 Miyamizu House/Exterior

Wisteria trellis

Miyamizu Shrine Kagura (Rough)

007-03 Miyamizu Shrine/Kagura

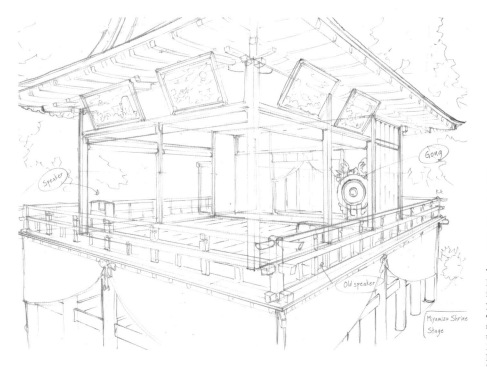

Speaker

Gong

Old speaker

Miyamizu Shrine Stage

007-04 Miyamizu Shrine/Kagura Stage

MIYAMIZU HOUSE/ MIYAMIZU SHRINE

The Miyamizu house is almost like a venerable Japanese inn; it even has outbuildings. If you look at the general map of Miyamori District, you can see that it's large compared to the neighboring houses. Miyamizu Shrine is located on high ground not far from the house and has a resplendently decorated kagura hall.

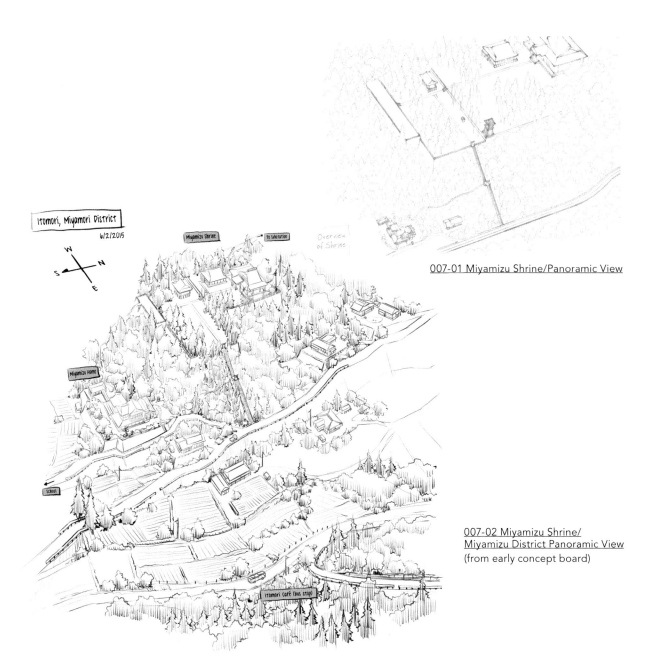

Itomori, Miyamori District
6/2/2015

Miyamizu Shrine
To Substation

Overview of Shrine

Miyamizu Home

School

Itomori Cafe (bus stop)

007-01 Miyamizu Shrine/Panoramic View

007-02 Miyamizu Shrine/
Miyamizu District Panoramic View
(from early concept board)

MAYOR'S OFFICE

There are no personal items here that would reveal anything about the father's personality. The sign that reads "Japan, River of Light" behind the desk in this image says "Indomitable" in the film.

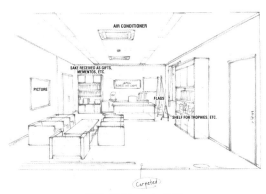

014-01 Mayor's Office

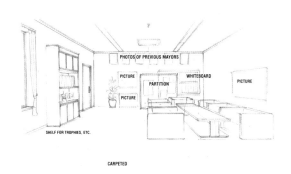

014-02 Mayor's Office/Reverse

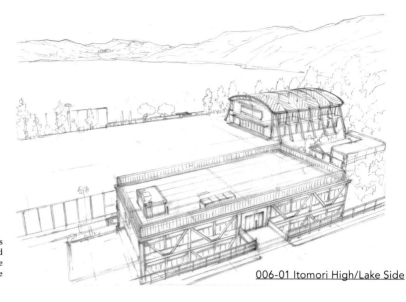

006-01 Itomori High/Lake Side

ITOMORI HIGH SCHOOL

Itomori High looks out over mountains and the lake. It was built on a lot carved out of the side of a mountain, and the main entrance is on the second floor of the school building, which faces the road.

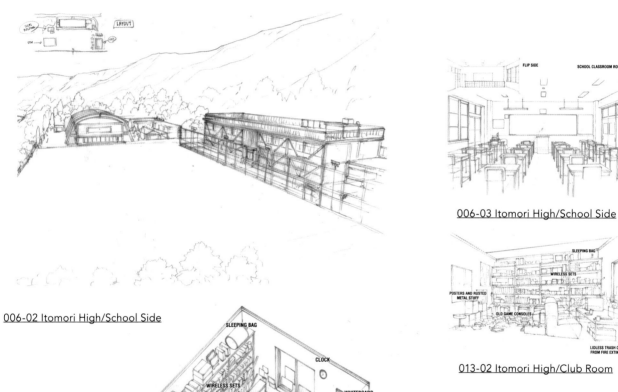

006-02 Itomori High/School Side

006-03 Itomori High/School Side

FLIP SIDE SCHOOL CLASSROOM ROUGH

SLEEPING BAG

WIRELESS SETS

POSTERS AND RUSTED METAL STUFF

OLD GAME CONSOLES

LIDLESS TRASH CAN MADE FROM FIRE EXTINGUISHER

013-02 Itomori High/Club Room

SLEEPING BAG

CLOCK

WIRELESS SETS

OLD COMPUTERS

WHITEBOARD

LIDLESS TRASH CAN MADE FROM FIRE EXTINGUISHER

MONITORS

This side

OLD GAME CONSOLES

WIRELESS SETS

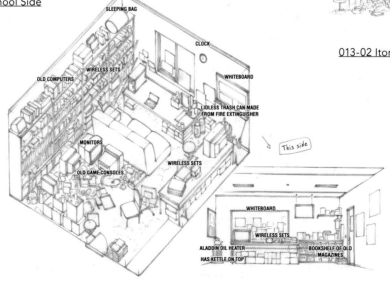

WHITEBOARD

WIRELESS SETS

ALADDIN OIL HEATER

BOOKSHELF OF OLD MAGAZINES

HAS KETTLE ON TOP

013-01 Itomori High/Club Room

TOKYO

According to the script, Taki lives in Wakaba, Shinjuku Ward. It's a central location in Tokyo, close to Yotsuya Station, and it was chosen because it's on higher ground than the rest of the area.

Here, we'll show you Taki's home and his high school.

TACHIBANA HOUSE

From the size and floor plan of the condo, it's a little big for two people, but it's pretty clear that the Tachibanas are a regular middle-class family.

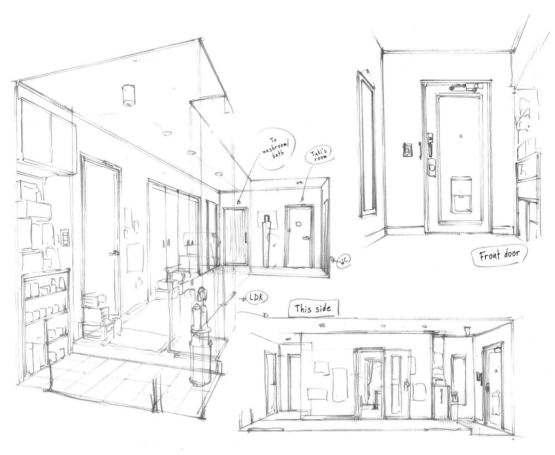

008-02 Tachibana House/Front Door/Hallway

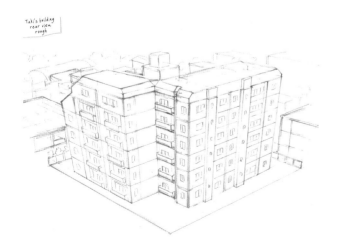

009-01 Tachibana House/Building Exterior

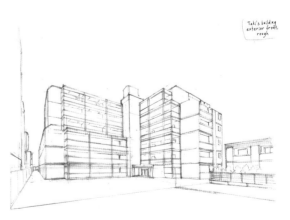

009-01 Tachibana House/Building Exterior

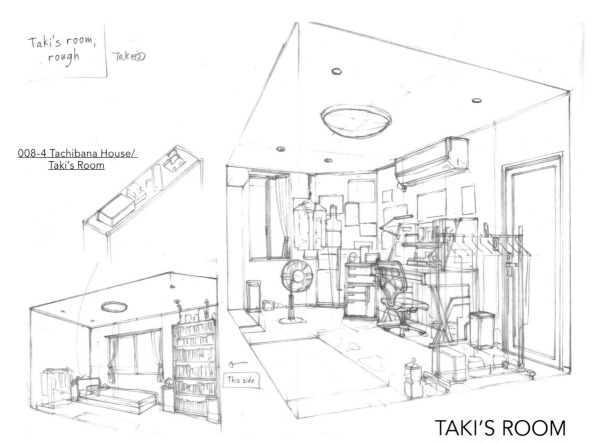

Taki's room, rough | Take③

008-4 Tachibana House/
Taki's Room

This side

TAKI'S ROOM

Appropriately for Taki, who's interested in architecture, this far-from-spacious room holds only what he needs, set out in an orderly fashion. In addition, the plain changing room eloquently displays the two men's simple lifestyle.

Taki's condo, changing room, washroom, rough

008-03 Tachibana House/Changing Room/Washroom

JINGU HIGH SCHOOL

Taki's high school was designed with a lot of windows and has a free, open atmosphere. The interior of the main school building is built around a central well, and students can play basketball on the roof. It's as if the Tokyo high school life Mitsuha longs for has been given a concrete shape.

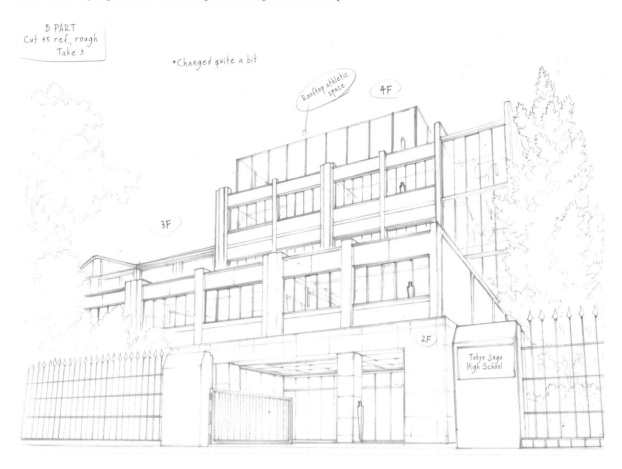

010-01 Jingu High/Exterior

010-02 Jingu High/Roof

010-03 Jingu High/Corridor

PROPS

The selection shown here focuses on Mitsuha's and Taki's accessories, which are typical for high schoolers. Mitsuha's braided cord is an important item in the film, and the final drafts of Mitsuha's and Taki's versions are shown as well.

Highlighter

Mechanical pencil

Ruler

Pen case (laminated pattern)

Compass

002-03 Taki/Writing Materials/Final Version

Taki school bag

001-02 Taki/School Bag/Final Version

Taki cell iPhone 6

Fastener

Taki, cord bracelet

005-03 Braided Cord/Final Version

| ART SELECTION |

Lip balm

Two-color
ballpoint pen

Highlighter

Mechanical
pencil

Pen case

"Milky"-type
candy

002-01 Mitsuha/Writing Materials/
Final Version

Mitsuha cell
iPhone 5

003-01 Taki & Mitsuha/
Cell Phone Comparison/
Final Version

Mitsuha school bag

Hedgehog strap

001-01 Mitsuha/School Bag/Final Version

005-01 Braided Cord/Final Version

AVANT-TITLE SEQUENCE

The storyboard is the vital blueprint for the film. It's packed with the director's thoughts about shot composition, character actions and lines, and the production intent for all these things. We've reproduced portions of it here.

Avan Page 1

Cut	Picture	Caption			Dur.

Picture: AVANT-TITLE
5/18/2015
9/17/2015
TITLE

Cut 0 / 01:12 / 1

Action Notes	Dialog	SE
Much of what's in the opening is reused in the film itself. There are a total of eight new art cuts: AV03, AV07, AV09, AV10, AV11, AV13 (partially reused later), AV14, and AV22 (partially reused later).		

Dur. 01:12

Cut 03:00 / 2 / 04:12

Action Notes	Dialog	SE
Zoom in, preceded by the sound of slicing through wind.		

Dur. 03:00 / 04:12

Dissolve 01:12

IN

OUT

Cut 1 / 08:19 / 1

Action Notes	Dialog	SE
E156 (7+0) reuse		
F.I. over 1+12 White smoke cuts across a blue that's close to dark navy. It's surrounded by dust that blazes up, then vanishes.		
Camera pans down, following the plunge, revealing a falling meteorite. A clear shadow of the smoke falls across the blanket of clouds. (Drop shadow on the atmosphere as well?)		

Sea of clouds

Dur. 08:19

The introduction is an important part of the movie that draws audiences into the story. The scene with the comet's fall, which appeared in the teaser as well, conveys the grand scale of the film.

Even in the storyboard, the way the meteorite plunges through several clouds communicates the speed at which it's falling.

Avan			Page 4
Cut	Picture	Caption	Dur.

IN
OUT

Action Notes **Dialog** **SE**
Once more, cloud
cuts across…

00 21
6

Action Notes **Dialog** **SE**
…right in front.

OUT

00:13
7
10:00

00 21

00:13
10:00

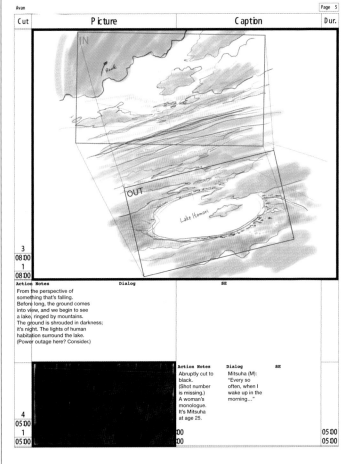

Avan			Page 5
Cut	Picture	Caption	Dur.

IN
Peak

OUT
Lake Itomori

3
08 00
1
08 00

Action Notes **Dialog** **SE**
From the perspective of
something that's falling.
Before long, the ground comes
into view, and we begin to see
a lake, ringed by mountains.
The ground is shrouded in darkness;
it's night. The lights of human
habitation surround the lake.
(Power outage here? Consider.)

Action Notes **Dialog** **SE**
Abruptly cut to Mitsuha (M):
black. "Every so
(Shot number often, when I
is missing.) wake up in the
A woman's morning…"
monologue.
It's Mitsuha
at age 25.

4
05 00
1
05 00

00 00
00 00

05 00
05 00

Once Itomori Lake is in sight, the screen cuts to black. Not showing the instant of the strike stirs the imagination regarding the story that's about to begin.

114

ART SELECTION

LINKED TO MUSIC

It's very clear that this scene was drawn with the assumption that a RADWIMPS song would play over it, and that the director thought about how to show the visuals in order to give priority to the song.

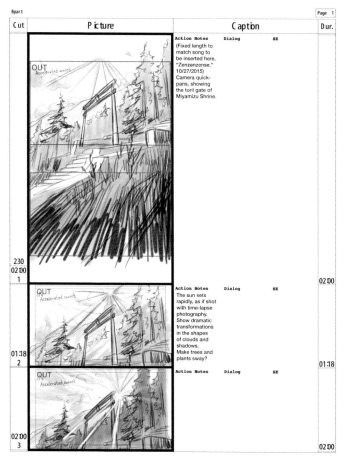

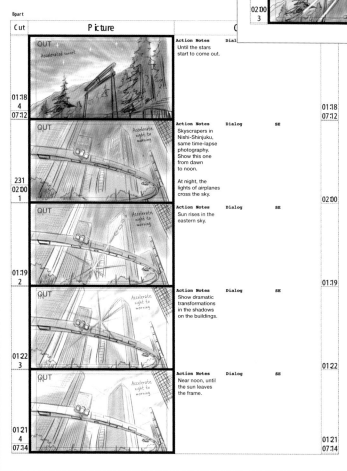

A scene that shows sunset in Itomori and dawn in Tokyo, synced to "Zenzenzense" and its feeling of speed.

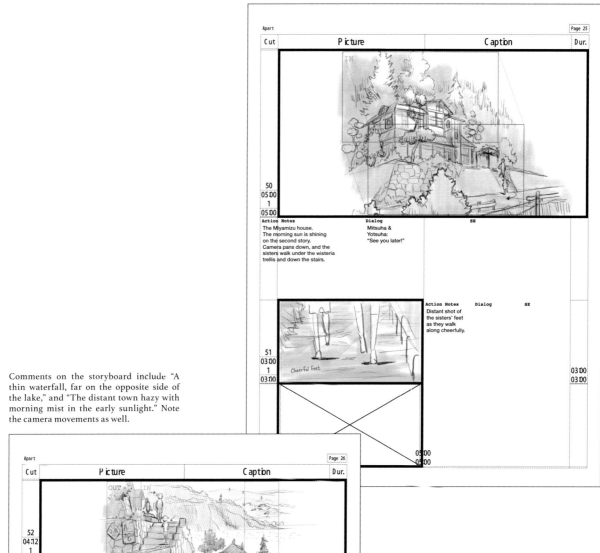

| Cut | Picture | Caption | Dur. |

50
05:00
1
05:00

Action Notes
The Miyamizu house.
The morning sun is shining
on the second story.
Camera pans down, and the
sisters walk under the wisteria
trellis and down the stairs.

Dialog
Mitsuha &
Yotsuha:
"See you later!"

SE

Action Notes
Distant shot of
the sisters' feet
as they walk
along cheerfully.

Dialog **SE**

51
03:00
1
03:00

Cheerful feet

03:00
03:00

05:00
05:00

Comments on the storyboard include "A thin waterfall, far on the opposite side of the lake," and "The distant town hazy with morning mist in the early sunlight." Note the camera movements as well.

Apart | Page 26

| Cut | Picture | Caption | Dur. |

OUT IN

52
04:12
1
04:12

Action Notes **Dialog** **SE**
A thin waterfall, far on the
opposite side of the lake.
The sisters go down through
the sloping hillside town.

Action Notes **Dialog** **SE**
Their backs
as they go
down the hill.
Multicamera pan
up, the town hazy
with morning
mist in the early
sunlight. (To
length 8+12)

OUT

IN

53
08:08
1
08:08

:12
:12

08:08
08:08

DETAILED BACKGROUNDS

On the storyboards, the backgrounds are substantially drawn in, and even details like the morning sunlight and the look of the town are included.

DIALOGUE AND SOUND EFFECTS

Detailed instructions for the timing of dialogue lines and sound effects are written in as well. Sometimes real photographs are used to convey specific images.

Cpart

Cut	Picture	Caption			Dur.

Cut 0 (01:00, 1)

Action Notes
*Unless there's a strong intent present, use video storyboard as the standard for dialogue/FX timing. Refer to the TC on each V.S. cut and calculate timing from there.

*No specified length for camera motion, so check these against the V.S. as well.

Dialog
*The numbers in the Cut # column are:

1. Cut number

2. Storyboard panel's length in the video storyboard

3. Number of the storyboard panel within this cut.

SE
That's it. I'm sorry it's hard to understand, but thanks in advance for your help! (Shinkai)

C PART — 2/13/2015 — 6/4/2015

Dur. 01:00

Cut 1 (01:06, 1)

Action Notes
A pencil drawing a long, smooth line.

Dur. 01:06

Cut 1 (01:05, 2)

Action Notes
It may be some kind of sketch; there are several other lines already. Pan to follow the pencil tip. Move focus as well.

Dur. 01:05

Cut (01:13, 3 / 04:00)

Action Notes
Maybe draw one smooth line all the way to the back, then several short, repeated strokes? Move a full length.

Dur. 01:13 / 04:00

Cut 2 (02:12, 1 / 02:12)

Action Notes
A pencil tip sketching, shown from a different angle. It seems to be feeling out the shape of the lakeshore. For example, about four rapid, short strokes, then draw one slow line. Camera, focus, handheld blur.

Dur. 02:12 / 02:12

The comment says, "I'm sorry it's hard to understand, but thanks in advance for your help! (Shinkai)," but the instructions are incredibly clear.

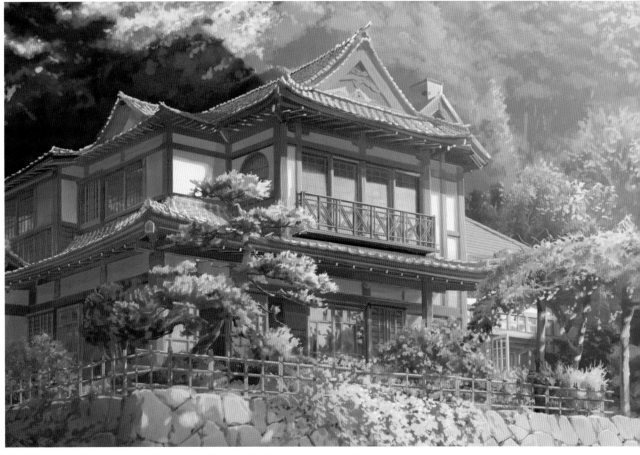

The historic Miyamizu house almost seems to be part of the natural environment that surrounds it.

BACKGROUNDS

ITOMORI AND TOKYO

The scenery of Itomori, like the unspoiled landscapes of Japan. Tokyo, drawn so exquisitely that it holds its own against the freshness and loveliness of nature. In Director Shinkai's hands, their beauty is astonishing.

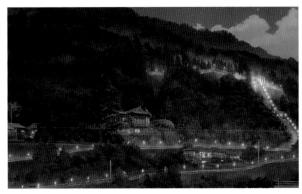

The night of the autumn festival. The lights illuminating the town feel nostalgic.

Itomori is overflowing with beautiful natural features that clearly show the turning seasons, such as these blazing autumn leaves.

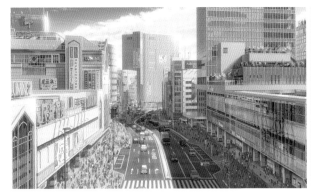

The street at the South Exit of Shinjuku, a terminal station that bustles with people.

The streets of Shinjuku, where blinking neon begins to glow as the sun goes down.

Even though it's the same natural greenery, it feels different in the heart of the city than in Itomori.

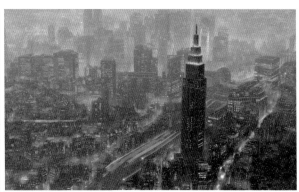

A tower that often appears in Shinkai films and serves as a Shinjuku landmark.

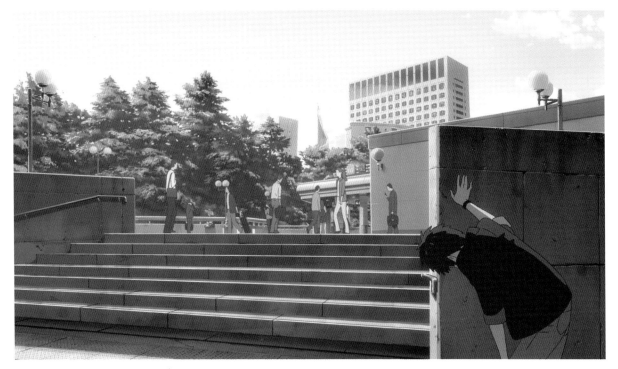

The area near the exit of the Yotsuya subway station.

LIGHT
AND
TIME

These landscapes appear for only a moment on the screen, but the passage of time and transformations in the light are meticulously depicted through incredibly subtle changes.

As the morning sun gradually illuminates the inorganic skyscrapers of the city, they seem almost like giants waking from a deep sleep.

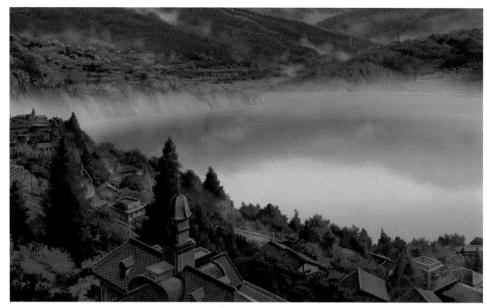

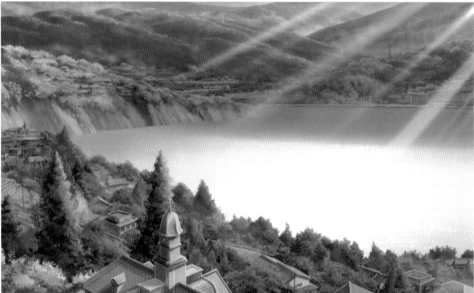

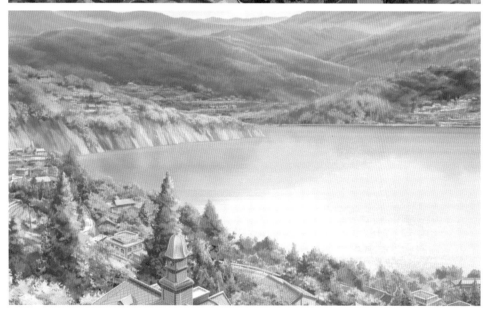

The morning mist on the water and the sunlight sparkling on its surface, Itomori Lake shows a different face from moment to moment.

A falling fragment of the comet, which split in the sky over Itomori. The light from it is bright enough to show the shapes of clouds in the night sky, and the fantastic image is reflected in Mitsuha's eye.

THE COMET

The terrible beauty of the falling comet. The sky and clouds that reflect it are varied as well. It's impossible not to gasp in admiration at that overwhelming light and at the comet's power.

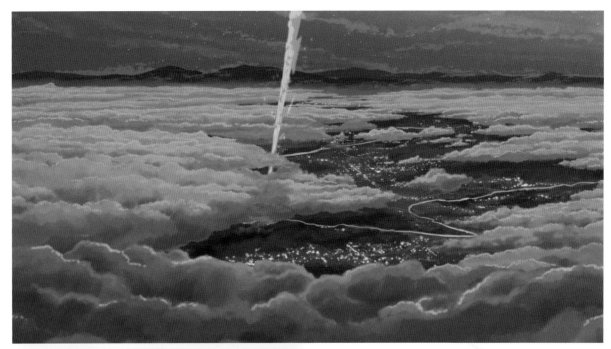

The comet falling through the sea of clouds that seems to enfold the town.

Just before the strike, the light of the comet is reflected in the surface of the lake.

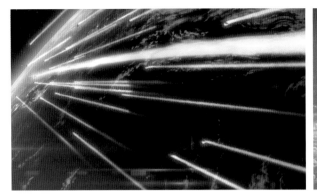 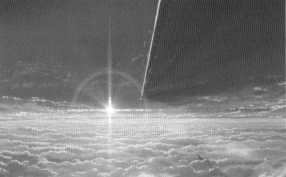

Comets streak over the Earth at terrific speed, while smoke stretches across a quiet blue sky like a scratch. Even though it's the same falling meteorite, the way it's shown creates completely different impressions.

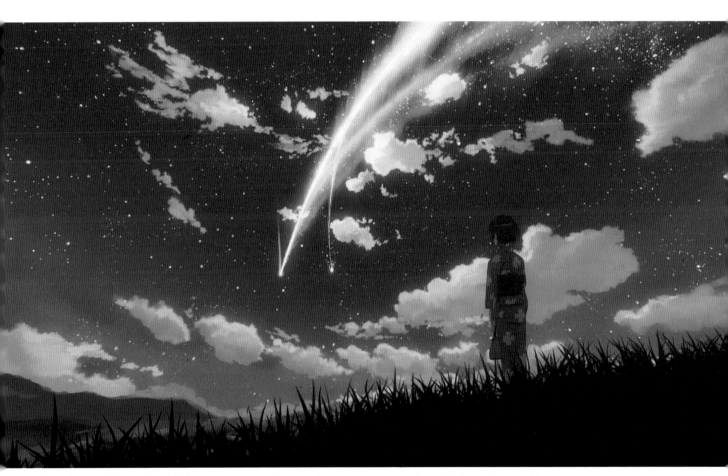

The afterimage of the comet's light is almost like an aurora. The massive damage it inflicts moments later makes its beauty seem awful.

"Joinin' threads, joinin' people, and the passage of time: They're all called *musubi*, and they're all the gods' power," says Mitsuha's grandmother, Hitoha.

THE FOLKLORE OF ITOMORI

Braided cords are the power of the god of *musubi*, of joining many into one. The divine will of Miyamizu Shrine was expressed through the patterns in the cords... An introduction to the folklore and traditions of Itomori.

A sacred tree in the mountains on the way to the body of the shrine's god. Sights like this show just how deeply rooted faith in the gods has been in Itomori since antiquity.

Mitsuha's family walked to the peak of the mountain, where the body of the shrine's god was located, in order to present the *kuchikamisake* as an offering. The mountain peak is a basin, and it isn't possible to see the sacred object from the outside.

The inside of the basin is a marsh, and a small river flows around the shrine's sacred object. The river is also the boundary that separates this world from the next.

Richly colored braided cords. The cords used in the harvest festival and other rituals are braided by the shrine maidens, Mitsuha and the others, one at a time.

A sketch of Itomori's scenery that Taki drew, relying on his memories. This drawing would eventually trigger Taki and Mitsuha's encounter across time and space.

The patterns of the braided cords hold a thousand years of Itomori's history, but their meaning was lost in a fire two hundred years ago.

立花 瀧　神木 隆之介

宮水 三葉　上白石 萌音

勅使河原 克彦　成田 凌

名取 早耶香　悠木 碧

藤井 司　島﨑 信長

高木 真太　石川 界人

宮水 四葉　谷 花音

宮水 トシキ　てらそま まさき
宮水 二葉　大原 さやか
瀧の父　井上 和彦
勅使河原の父　茶風林
勅使河原の母　かとう 有花
ユキちゃん先生　花澤 香菜

寺崎 裕香	小野塚 貴志	滑川 洋平
辻 美帆	浜添 伸山	佐藤 奏美
合田 慎二郎	菊池 康弘	ひなた たまり
山根 希美	新 祐樹	村上 遼哉
長谷川 曜	バロン 山崎	珠希 美碧
井上 優	宇佐美 涼子	森﨑 美穂
南嶋 毅	大前 愛華	山口 智大
中務 貴幸	松川 央樹	根来 彰子
大南 悠	塙 愛美	田端 美保
松坂 愛子	富岡 英里子	山本 栄司
ラヴェルヌ 知輝	大川 春菜	池田 優也
兼光ダニエル真	C.Elliott Wong	スタンザーニ・ピーニ詩文奈
Chris McKenna	桑原 彰	武田 祐介

宮水 一葉　市原 悦子

貴寺 ミキ　長澤 まさみ

製作　市川 南 / 川口 典孝 / 太田 圭二

企画・プロデュース　川村 元気

エグゼクティブプロデューサー　古澤 佳寛

原作・脚本・絵コンテ　新海 誠

キャラクターデザイン　田中 将賀 / 安藤 雅司

音楽　RADWIMPS

作画監督　安藤 雅司 / 井上 鋭 / 土屋 堅一 / 廣田 俊輔 / 黄瀬 和哉

演出　居村 健治

原画

稲村 武志	濱洲 英喜	本間 晃
井上 鋭	土屋 堅一	廣田 俊輔
田中 敦子	賀川 愛	箕輪 博子
西村 貴世	岩崎 たいすけ	岸野 崇驚
小林 直樹	田澤 潮	高士 亜衣
古川 尚哉	中村 悟	松尾 真理子
竹内 旭	松永 絵美	龍輪 直征
水野 良亮	河原 奈緒子	土屋 亮介
松村 祐香	大橋 実	荒木 裕
渡辺 裕二	齋藤 直子	山本 早苗
竹内 一義		
太田 衣美	千葉 崇洋	末冨 慎治
竹縄 利名	福田 さちこ	春日 広子
小西 紗希	奥野 治男	五反 孝幸
下妻 日紗子		
松本 憲生	沖浦 啓之	橋本 敬史

オープニング作画監督　田中 将賀

オープニング原画　錦織 敦史　谷口 淳一郎　岩崎 たいすけ / 滝本 祥子　大館 康二　落合 瞳 / 田中 将賀

応用シーン演出・原画・撮影　四宮 義俊

特効彩色　皆川 真紀　室岡 侑奈　島子 美菜子 / 松田 大介　MATEUSZ URBANOWICZ

3DCG　吉野 耕平　金子 範　竹内 良貴

脚本協力　加﨑 新太

プロップ設定　岩崎 たいすけ

巫女舞創作・著村　中村 壱太郎

動画

中込 利恵	秋田 雅子	林 佳枝	松浦 結
松田 裕美	松岡 理恵子		
鈴木 香理	黒田 亜理沙	深沢 純怜	山本 晃弘
土岐 弥生	横田 喜代子	東 誠子	富沢 恵子
村松 さつき	矢地 久子	藤森 まや	大谷 久美子
椎名 律子	長命 幸佳	玉置 雅代	安東 雅代
古木 優	田名部 節也	宮川 かおり	田中 立子
熱田 幸永	芝崎 みゆき	佐藤 恭子	堀 裕津
榎本 柊斗	中嶋 智子	水野 良亮	松村 祐香
真野 鈴子	大村 まゆみ	手島 晶子	大橋 実
玉腰 悦子			

谷平 久美子	山浦 由加里	小山 正清	大谷 茜
齋藤 彩圭	村橋 亮佑	本田 康明	山本 芽以
岩切 君枝	辻 仁子	小川 麻衣	甲斐 順子
藤中 友里	赤坂 莉奈	大口 茜	坂詰 かよ
劉慈英	韓松照	徐允珠	河承希
金斑愛	朴蘭姫	金貞鬪	金貞順
鄭玄貞	Hwang Sun hee	Jo Jee Young	Ku Gyunh Yok
Hu Kyung Hee	Song Tae Kwang	Kim Sin Sung	黄順河
安美京	LEE BOREUM	富田 美穂子	水口 貴善
小谷 雛美	下平 夕子	戸井田 宙	根本 奈実
岸井 沙織	吉村 千秋	池田 遥	合田 良太
山田 啓文	福富 絢子	陸井 優花	澤井 駿
森 慶彦	小保方 千奈	渡辺 真紗子	飯盛 夏子
川口 理佳	千葉 大輔	与澤 桂子	北郷 由美子
須崎 かおる	関 夏実	張相美	仙波 里至
山口 なつみ	菅原 菜津美	山崎 茜	國分 瑞生
柳澤 彼方	原科 大地	大山 神	田中 寄樹
藤原 舞似子	徳田 靖	市村 友美桂	和田 凜花
高野 陽司	豊田 創	山本 彩加	大曽根 唯
堀内 正康	櫻井 加乃子	和泉 晃耶	楳本 穂高
岡野 毅	山崎 奈緒美	奥 舞	佐藤 加奈
太田 慎之介	中川 三由紀	衛藤 千広	清原 寮
衰容吾	金福心	金成范	張智程

美術監督　丹治 匠 / 馬島 亮子 / 渡邊 丞

美術設定　高橋 武之

美術設定協力　滝口 比呂志

美術背景

廣澤 晃	瀧野 薫	泉谷 かおり
MATEUSZ URBANOWICZ	友澤 優帆	小原 まりこ
宇佐美レオナルド健	中島 健太	斉藤 未来
上田 瑞香	中村 瑛利子	本田 敏恵
劇田 美菜子	渡邉 丞	馬島 亮子
丹治 匠		
後藤 俊彦	松田 大介	里見 篤
室岡 侑奈	松本 吉勝	長澤 順子
中右 智博	黒澤 成江	侯 荻
森川 みず穂	小畑 盛二	上遠野 祥子
増山 修	木下 晋輔	加藤 綾乃
小山 真和	妹尾 想	石﨑 朋佳
西口 早智子	金哲圭	甲国真

色彩設計　三木 陽子

色指定検査　仲條 貫子

色指定検査

忽那 亜実	久力 志保	関根 里枝子	
日比野 仁美	渡辺 康子	佐藤 加奈子	大野 千紘
川上 優子	村田 寧々		

デジタルペイント

野口 幸恵	高谷 知恵	原田 裕作	田中 英里那
倉田 玖	黒瀬 友哉	永延 春樹	飯島 理恵
早川 恵美	斉藤 あや子	及川 眞由美	橋本 千春
角下 瑞絵	石倉 瑞久	西田 みのり	圓次 美和
牛山 裕美	利根川 友紀	相澤 里佳	福田 友理恵
安藤 佳奈美	佐藤 恭子	田村 貴子	星川 麻美
宮原 奈緒子	衛 龍介	小柳 寿志	畑中 章行
横瀬 貴幸	中平 香織	田中 怒詩	末繁 明佳

動画検査

玉腰 悦子 / 真野 鈴子 / 大村 まゆみ / 手島 晶子 / 大橋 実

青木 優佳　安藤 のぞみ　入江 千尋　小山 知子
小松 亜理沙　鈴木 咲絵　武田 仁基　比嘉 あきの
藤原 道乃　堀内 菜央　森脇 弘史　木下 美佳
橋本 侑香里　村瀬 瞳美　角 美智子　沼田 千晶
都丸 優斗　近藤 直登　岩崎 静夏　塚田 和也
大枝 優斗　渡辺 郁也　太田 薫　中野 夏帆
千葉 涼香　池田 優華　篠原 絢子　若井 あゆ
岸下 真紀　玉木 千春　角 智美　渡邊 絵梨
松浦 友紀　佐藤 博美　佐藤 はじめ　戸澤 友紀
髙橋 聖美　杉山 智恵　中原 あゆみ　内海 太輔
加藤 笑子　丸山 香　加藤 友美　浦 大器
文聖惠　安榮愛　鄭惠羅　辛賢貞
崔秀庚　田股珠　金銀姫　李研珠
韓明善　Kim Hee Jung　Seok Young Suk　Gang Nam E
Lee Yoo Kyoung　Oh Jin Hee　Kang Hee Kyoung　權五淑
權美羅　朴ユリ　李寶藍　李珍姫
金美正　金吹正

劇中使用曲

「豊醸舞」　「in a little while」　「古いオルゴール」
作曲：村山 二朗　作曲：櫛井 隆仁　作曲：櫛井 隆仁

「春NewVer」　「高原」
作曲：牧野 奈津子　作曲：UNi-PEX
© 2004 サウンドフォーラム　© ユニペックス
Licensed by スイッチ　Licensed by スイッチ

音楽プロデューサー　成川 沙世子

音楽ミキサー　菅井 正剛　澤本 哲朗
　　　　　　Tom Lord-Alge　長谷川 巧
音楽ディレクター　山口 一樹
ストリングス協力　德澤 青弦
音楽エディター　金貞 陽一郎
アーティストリレーションズ　田島 隆　渡辺 雅敏
　　　　　　堀越 智彦　綱嶋 容子
　　　　　　桂川 賢一　佐藤 夕香
音楽協力　藤沢囃子保存会　深澤 恵梨香

撮影チーフ　福澤 瞳

撮影　三木 陽子　李 周美　藤田 賢治
　　　津田 涼介　八木 昌彦　岩井 和也
　　　新海 誠

撮影協力　江藤 慎一郎　宋 守貞　岡 淑子
　　　　江上 玲　土屋 康次　衛藤 直毅
　　　　髙瀬 勝　田中 英里那

テクスチャー　市川 愛理　小野 麻美　清水 由香
　　　　　三木 陽子　落合 千春

編集　新海 誠

デジタルラボ　IMAGICA

オンライン編集　増永 純一
カラーマネジメント　由良 俊樹
デジタルシネママスタリング　新谷 彩　浅井 恵衣
ラボコーディネーター　河野 紅美子
編集ラボマネージャー　小川 輝　水谷 真理

3DCGチーフ　竹内 良貴

3DCG　宮原 眞　河合 完治　山元 隼一

制作プロデューサー　酒井 雄一

制作進行　岡村 慎治　遠藤 陽平　植田 祐
　　　　堀 雄太　LEOW LEE WON

音響監督・整音　山田 陽

音響効果　森川 永子

効果助手　林 佑樹

アニメーション制作協力　アンサー・スタジオ
制作プロデューサー　木曽 由香里　鈴持 耕平
制作デスク　中目 貴史
制作進行　吉信 慶太　富岡 隆大

制作協力　Production I.G　スタジオカラー　TROYCA
　CLIP+BISON.LLC　スタジオシャムロック
　シャフト　アニメ TORO TORO　オープロダクション　マッドハウス
　ゴンゾ　中村プロダクション　オレンジアニメーション　HANJIN
　マア・モビックス　すたおかぐら　テレコム・アニメーションフィルム
　ライジングフォース　和風アニメーション　ゼクシズ　スタジオ・マーク
　M.S.C　スタジオギムレット　アニタス神戸　アングル　イングレッサ
　キャンディーボックス　作楽クリエイト　ラインファーム　オフィスフウ
　D-COLORS　T2studio　スタジオタージ　ライトフット　DR MOVIE
　Alpaca Pictures　ファインカラーズ　スタジオエル　マウス　デファー
　プロダクション・アイ　クリープ　インスパイアード　TYOアニメーションズ
　東宝ミュージック　ちゅらサウンド　サウンドインスタジオ
　ユニークブレインズ　三交社

録音　八巻 大樹
録音助手　椎葉 ひかる

音響制作　サウンドチーム・ドンファン

方言監修　かとう 有花

キャスティング　増田 悟司　大口 星子
　　　　　　有馬 加奈子

アフレコスタジオ　studio Don Juan

ダビングステージ　東宝スタジオ
東宝スタジオコーディネート　西野尾 貞明　立川 千秋
スタジオエンジニア　竹島 直登
スタジオアシスタント　佐野 優介
テクニカルサポート　菊地 秀穂　越 真一郎

「君の名は。」
(ユニバーサル ミュージック/EMI Records)

主題歌

「夢灯籠」　「前前前世 movie ver.」
RADWIMPS　RADWIMPS
作詞・作曲：野田 洋次郎　作詞・作曲：野田 洋次郎

「スパークル movie ver.」　「なんでもないや movie ver.」
RADWIMPS　RADWIMPS
作詞・作曲：野田 洋次郎　作詞・作曲：野田 洋次郎

取材協力　井上 史也　吾妻 あや子　松本 窓
　　　　平田 組組　シェアードテラス　四谷 須賀神社
　　　　国立新美術館　森ビル

協力　栄光ゼミナール　大塚商会　学研プラス　月刊ムー編集部
　　すかいらーく　東京スクール・オブ・ビジネス　福美人　ヤマダ電機
　　meiji 明治　YUNIKA VISION　Z会

東宝スタジオ　東宝スタジオサービス　togen
東宝ポストプロダクションセンター　ZENRIN　Mapion

宣伝プロデューサー　薄澤 康弘　弭間 友子　水木 雄太
宣伝　秋山 智美　下森 翠　飯島 清香
　　幕内 一男　福地 雄士　中内 麻友
　　篠原 麻由子　松成 憲二　西村 公佑
　　橋本 尚香　川口 唯子

宣伝デザイン監修　落合 千春　市川 愛理

オフィシャルライター　渡辺 水央
予告編ディレクター　依田 伸隆
予告編制作進行　髙根 英一郎　岩﨑 友佳
グラフィック制作　BALCOLONY.
公式サイト制作　BALCOLONY. & TRIBALCON.
メイキング制作　ナカマオフィス

書籍編集　関口 靖彦
出版・宣伝協力　吉良 浩一　今井 理紗　長山 俊輔
　　　　　　遠藤 美希　井坂 皆美　石井 千香子

海外担当　菊地 裕介　竹田 晃洋　中澤 小枝　町田 瑞衣
商品化担当　田中 敬子

助成　文化庁文化芸術振興費補助金

スペシャルサンクス　岩井 俊二　三坂 知絵子　松下 慶子
　　　　　　石井 朋彦　阿部 良弘　白鳥 貴子
　　　　　　岡島 隆敏　宗宮 一輝　加藤 友宜
　　　　　　水野 昌　圀枝 信吾　倉田 泰輔

プロデューサー　武井 克弘
　　　　　　伊藤 耕一郎

「君の名は。」製作委員会

共同製作　井上 伸一郎
　　　　弓矢 政法
　　　　畠中 達郎
　　　　善木 準二
　　　　坂本 健

東宝　山内 章弘　上田 太地　小野田 光　鎌田 周平
　　大島 孝幸　藤田 雅規　大浦 俊将　高橋 敦司
コミックス・ウェーブ・フィルム　角南 一城　小川 智弘　武田 真理子
KADOKAWA　堀内 大示　菊池 剛　工藤 大丈　菊池 憲文
ジェイアール東日本企画　相原 勉　土生 宏匡　飯岡 浩司
アミューズ　千葉 伸大　遠藤 日登思　久保 美夏
voque ting　塚原 聡
ローソンHMVエンタテイメント　盛谷 尚也　長田 史郎　春田 英彦　広瀬 春奈　濱田 健太郎

製作　コミックス・ウェーブ・フィルム

監督　新海 誠

STAFF

Designer
Hiroyuki Kato

Writers
Mizuo Watanabe
Hitomi Wada
Motoki Kurata

Photography
Yuji Hongo (Pages 54–58)
Mikio Shuto (Pages 50–53, 66, 69–70, 72, 74–80)
CoMix Wave Films
(Pages 56, 59, 62–63, 65, 68, 72–73)

Editors
Aki Kishimoto
Yoshimi Kato
Tomoko Hirano

Editorial Cooperation
CoMix Wave Films
Airi Ichikawa
Yu Ueda
Yohei Endo
Asami Ono
Hiromoto Fukushima
LEE WON LEOW

Editorial Supervisor
Toho
Katsuhiro Takei
Satomi Akiyama

CoMix Wave Films
Chiharu Ochiai

Special Thanks
Makoto Shinkai

Costume
ADONUST MUSEUM (03-5428-2458)
ALLSAINTS (03-6433-5159)
HIGH BRIDGE INTERNATIONAL (03-3486-8847)
Honor gathering (03- 3409-3015)
licht bestreben (03-5697-1525)
lot holon (03-6418-6314)
THEE OLD CIRCUS (03-6277-2947)
TROVE (03-3476-0787)

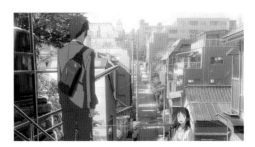

your name. The Official Visual Guide
by Makoto Shinkai
Translation: Taylor Engel
Lettering: Abigail Blackman

A Makoto Shinkai film your name. The Official Visual Guide
© 2016 TOHO CO., LTD. / CoMix Wave Films Inc. / KADOKAWA CORPORATION / East Japan Marketing & Communications, Inc. / AMUSE Inc. / voque ting co., ltd. / Lawson HMV Entertainment, Inc.

© 2016 KADOKAWA CORPORATION

First published in Japan in 2016 by KADOKAWA CORPORATION, Tokyo. English translation rights arranged with KADOKAWA CORPORATION, Tokyo through TUTTLE-MORI AGENCY, INC., Tokyo.

English translation © 2021 by Yen Press, LLC

Yen Press
150 West 30th Street, 19th Floor | New York, NY 10001

Visit us at yenpress.com
facebook.com/yenpress | twitter.com/yenpress
yenpress.tumblr.com | instagram.com/yenpress

First Yen Press Edition: June 2021

Yen Press is an imprint of Yen Press, LLC.
The Yen Press name and logo are trademarks of Yen Press, LLC.

The publisher is not responsible for websites (or their content) that are not owned by the publisher.

Library of Congress Control Number: 2019948592

ISBN: 978-1-9753-5871-6 (paperback)

10 9 8 7 6 5 4 3 2 1

APS

Printed in China